Christmas IN *Cleveland*

Christmas IN *Cleveland*

ALAN F. DUTKA

THE
History
PRESS

Published by The History Press
Charleston, SC
www.historypress.com

First published 2020

Manufactured in the United States

ISBN 9781467146722

Library of Congress Control Number: 2020941937

Contents

Preface

I was born and raised in Cleveland at the proper age to vividly recall the glorious department store Christmas windows, lights on Public Square and gigantic Sterling-Lindner-Davis Christmas trees. But I must have grown up much too fast or spent too much time in an alternate universe because viewing the Sterling trees never seemed to be as fun as feasting on a sirloin steak or a hamburger, followed by a hot fudge sundae, in a downtown restaurant. Shopping with my mother at the age of six, I was amused by the animated Christmas windows at the Halle department store for no more than two minutes. Viewing the Stillman Theater's marquee across the street, I suggested to Mom that, since she must have been pretty tired having already reaching the advanced age of forty-three, maybe we could rest while watching *The Three Musketeers*. I had never heard of either Lana Turner or Gene Kelly, but as she was a fan of both, I got my wish.

My most vivid Christmas memory occurred on December 25, 1959, when I spent about ten hours downtown laboring in the dark. As an usher at the Stillman Theater, I toiled from noon until 10:00 p.m., with one thirty-minute break to grab a hamburger and milkshake at LaMar's Restaurant across the street in the CAC Building. The line to purchase tickets that Christmas day started at 11:00 a.m. and didn't end until the box office closed at 10:00 p.m. Thanks to full-page advertisements in the *Plain Dealer* every Sunday from Thanksgiving to Christmas, along with radio and television commercials, the opening of the biblical epic *Solomon and Sheba* produced the second-largest moneymaking day in the history of the theater.

After conducting research for this book, I can't believe that I was so indifferent toward the wonders of celebrating Christmas in Cleveland. For all of you who had a better appreciation for the holiday season, or if you would like to learn more about what you missed due to age or apathy, here is my best attempt at re-creating Cleveland's holiday seasons starting as far back as the earliest pioneers.

Acknowledgements

Members of three different departments at the Cleveland Public Library contributed to this book: photographs (Brian Meggitt and Adam Jaenke), history (Olivia Hoge, Terry Metter, Danilo Milich, Lisa Sanchez and Aimee Lepelley) and special collections (Stacie Brisker and Bill Chase).

At Cleveland State University, William C. Barrow in special collections and Vern L. Morrison made contributions in obtaining images and providing insights.

Saint John Cathedral, the Cleveland Ballet, the City Ballet of Cleveland and Great Lakes Theater provided beautiful images, as did M.O. Ghorbanzadeh. Priscilla Dutka, once again, provided her amazing proofreading skills and special insights.

Lastly, I would like to thank John Rodrigue and Ashley Hill from The History Press.

Introduction

Christian missionaries considered Cleveland's first settlers heathens because of their lack of interest in Christmas. Yet today, magnificent churches enhance the landscapes of almost every Cleveland neighborhood.

As early as 1881, Cleveland's department stores displayed Christmas merchandise and decorations on the Friday following Thanksgiving. Eighty years later, in 1961, readers of the *Plain Dealer* conveyed their extreme dissatisfaction with rushing the season when stores exhibited Christmas decorations a week prior to Thanksgiving:

> *Two weeks before Christmas should be enough time for decorating and really getting into the swing of things.*

> *My husband and I are doing our own private boycotting by not mentioning Christmas until after Thanksgiving and refusing to allow our children to listen to TV Christmas shows.*

> *Starting this early to think, speak and display Christmas is a punishment to children; to make them aware of Christmas so far ahead is a cruelty beyond the realm of human dignity.*

Many of the enclosed malls that were so instrumental in ending downtown's once near monopoly on Christmas shopping have been

demolished. Most of the great downtown department store buildings remain in existence, but they are no longer shopping meccas. The structures that were once home to the Taylor and May Companies now accommodate luxury apartments. The Halle edifice is a combination apartment and office building. The Higbee department store building is now a casino with office space on the higher floors. A portion of the Sterling-Lindner-Davis complex is an office building; another segment houses a parking lot. The Bailey site is a multistory parking garage with a ground-floor restaurant.

Today, many Clevelanders prefer laptop computers to radios and record players for enjoying Christmas music. Social media and email have diminished the importance of the post office in delivering holiday greetings. The giant downtown movie screens have been superseded by downloading and streaming alternatives. The internet is challenging the importance of brick-and-mortar stores for Christmas shopping supremacy. Yet through decades of change, Clevelanders still worship in church services, gather for family dinners, attend holiday stage productions and relish giving and receiving holiday presents. Beginning with Cleveland's first settlers, *Christmas in Cleveland* surveys the local holiday scene through two hundred years of remarkable excitement and change.

Celebrating the Season

*C*leveland's pioneers expressed little interest in celebrating Christmas; in fact, many held holiday merriment in downright disdain. Clearing towering trees, constructing makeshift log cabins and plowing and cultivating what they hoped would become fertile farmland didn't stimulate gaiety and laughter. Life-threatening encounters with four-foot-long venomous rattlesnakes, four-hundred-pound black bears, packs of wolves, wandering wildcats, two-hundred-pound panthers and herds of wild hogs did nothing to improve their predicament. Even so, early Clevelanders relished the boisterous Fourth of July celebrations they initiated shortly after arriving in the pristine territory. The pioneers' aversion to Christmas festivities stemmed mostly from a firmly established disapproval of the idea of the holiday itself.

Thomas Robbins, an early missionary in Northeast Ohio, described the settlers as being openly hostile toward religion. Pioneer Moses White hesitated to expose his wife to a territory that had acquired a reputation for being a "heathen land" and "Godless community." Yet the most devout Christians also ignored Christmas celebrations. The Puritan American contempt for extolling Christ's birth dates back to Plymouth, Massachusetts. Even prior to a Puritan-led Parliament outlawing Christmas celebrations in England, the Plymouth pilgrims demonstrated their disapproval of Christmas festivities by purposely engaging in hard work on their first December 25 in the New World. William Bradford, the colony's governor, once chastised a group of

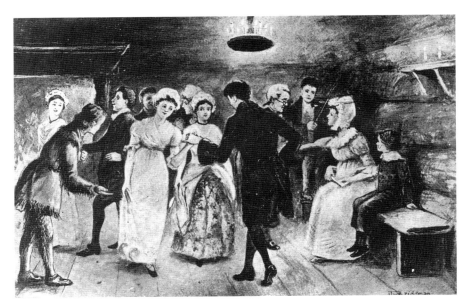

Cleveland's first large social event, a festive Fourth of July ball at Lorenzo Carter's cabin in 1801, preceded the city's Christmas Day celebrations by decades. *Courtesy of Cleveland Public Library, Photograph Collection.*

boys for engaging in playful games on Christmas Day and presented a clear directive: "Work or go to jail."

In 1659, Massachusetts passed a law declaring Christmas celebrations criminal offenses: "Whosoever shall be found observing any day such as Christmas or the like…shall be fined five shillings." The penalty increased for repeat offenders or others the court deemed as incorrigible or defiant sinners. Massachusetts citizens could not legally work less or eat more on December 25 than any other day of the year; even wishing a neighbor "Merry Christmas" could theoretically result in a fine. The formal Christmas ban remained in force for twenty-two years, although no arrests occurred when celebrants confined revelry to their private homes. Even after the repeal of the law, disapproval of celebrations remained for decades. Following the American Revolutionary War's conclusion in 1783, Christmas rejoicing remained out of favor, partly because of its association with English custom.

Cleveland's stern Puritan pioneers viewed holiday gaiety as lacking biblical justification and felt it encouraged wasteful and immoral behavior, including drunkenness and swearing. An 1823 newspaper advertisement tersely described the village's biggest holiday event: shooting geese, pigs and dunghill fowls for nine cents a shot. The first large community Christmas

14

celebration in Northeast Ohio took place in 1833, near the present-day site of Shaker Square. Organized by a colony of Shakers, the worship ceremony consisted of singing sacred songs and performing admired dances, all written and arranged by the local Shakers. Yet into the 1840s, many Clevelanders still considered holiday celebrations as desecrations of a revered event.

A significant change in attitudes toward Christmas celebrations occurred in the 1840s. First published in 1843, Charles Dickens's classic *A Christmas Carol* dramatically examined the true spirit of Christmas, and in the process, it initiated interest in reviving holiday celebrations. In England, Queen Victoria and her German husband, Prince Albert, unabashedly celebrated Christmas. Locally, a large wave of Irish and German immigrants provided additional inspiration for rejoicing in Christ's birth. In 1856, before Ohio declared Christmas a legal holiday, Cleveland's downtown hotels served elaborate and well-attended late-afternoon Christmas dinners that were followed by viewing a standing-room-only performance of *The Last Days of Pompeii* at the Cleveland Theater on West Sixth Street, attending a ball at Grey's Armory or listening to a lecture in defense of spiritualism at a downtown hall. Through the years, actors who devoted Christmas Day to entertaining audiences on Cleveland stages included Ethel Barrymore, George M. Cohan, Fanny Brice, Judith Anderson, Ed Wynn, Ethel Waters, Tyrone Power, Jose Ferrer, Ann Miller, Ted Lewis, Perry Como, Marilyn Miller, Artie Shaw, the Mills brothers, Henny Youngman and hundreds of other first-rate actors and supporting players.

In 1836, Alabama became the first state to declare Christmas an official holiday; Ohio followed suit in 1863. President Ulysses S. Grant declared Christmas a legal national holiday in 1870. Two years before, Louisa May Alcott began her *Little Women* tale with the opening line: "Christmas won't be Christmas without any presents." By the end of the Civil War, Clevelanders almost universally observed Christmas as a holiday, although their behavioral expectations didn't reach the highest of levels. The *Plain Dealer* reported that Christmas Day in 1865 was "beautiful and passed without any remarkable events, except for several fights, some drunks and a few arrests."

Late nineteenth-century holiday celebrations produced their share of less than Christian goodwill. On December 25, 1891, police arrested James P. Fagan (also known as Pat Murphy, James P. Morrison and James Robinson) for defrauding the public. Fagan convinced gullible people walking down Woodland Avenue that he represented a nearby church, so contributions given to him would be used to dedicate a mass in their honor. On the same day, Tony Williams incurred a fifty-dollar fine for

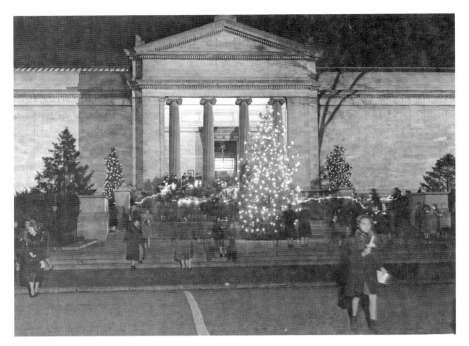

Holiday visitors exited the Cleveland Museum of Art in 1966, fifty years after its opening and seventy-four years since Jeptha Wade's Christmas gift of land helped establish the museum. *Courtesy of Cleveland Public Library, Photograph Collection.*

providing Flora McGee, his girlfriend, with twin Christmas presents of two black eyes. But plenty of good cheer developed the next year, when Cleveland received what may have been its best Christmas present ever. On December 25, 1892, millionaire Jeptha Wade donated a tract of land to house an art museum. The Cleveland Museum of Art was eventually constructed on the site.

As the nineteenth century concluded, Cleveland's hotels continued their appetizing custom of serving Christmas dinners and even printed souvenir menus for the occasion. The Kennard House, which was situated on St. Clair Avenue at West Sixth Street, created a menu that consisted of a blue folder tied with a red ribbon and fastened by a bright-red seal embossed in gold lettering that wished its guests a "Merry Christmas."

The early twentieth century's holiday seasons generated their share of grinches, especially on Euclid Avenue. On Saturday, December 23, 1905, the final day of the season's Christmas shopping, a woman brushed against Mrs. Alice Doll in a Euclid Avenue building and stole seventy-five dollars from

her pocket. At another extreme, also on Euclid Avenue, a pickpocket robbed George Kirby, an elementary school child, of eighty-eight cents. Posing as a customer in a fancy avenue jewelry shop, a well-dressed lady asked to inspect several diamond rings. Before the salesperson realized the switch, the lady had replaced a seventy-five-dollar ring with a substitute that was valued at less than a quarter of the parcel she had pocketed. The following Christmas season, extra uniformed policemen, along with plainclothesmen and bicycle patrolmen, guarded Euclid Avenue and Ontario Street, looking for shoplifters, pickpockets and a set of thieves who were stealing packages from delivery trucks.

In 1915, merchants employed colored cardboard signs in store windows to indicate their need for a package pickup. Twenty-two-year-old Henry Miller, a resident of East Fifty-Fifth Street, established a thriving business by posing as a pickup service and then selling the merchandise he collected. At a time when the country's median household income was $687, Miller earned about $6,000 per year stealing packages—mostly during the Christmas season—from shops in Cleveland, New York, Chicago and Detroit. He once stole a $300 fur coat from Cleveland's Higbee Company. When he was apprehended by the Cleveland Police, Miller asked a detective to meet his girlfriend to explain why he couldn't make their planned date. The detective denied his request.

Violence marked the Christmas Eve of 1918, when two men entered Euclid Avenue's crowded Thompson Restaurant with the intent to commit a robbery. While pilfering the cash register, sixteen-year-old Thomas Gerak shot the cashier to death. The two robbers escaped onto a congested Euclid Avenue, but police later apprehended both men. A court sentenced Gerak to life in prison without hope of parole. While serving his jail term, he cut through the bars of a prison chapel window and escaped. Following his capture and return to prison, Gerak joined twelve other inmates in a failed attempt to shoot their way to freedom. In 1935, outgoing Ohio governor George White pardoned Gerak. Two years later, Gerak killed a man during an altercation following a minor traffic accident.

In 1913, Cleveland inaugurated a "community Christmas celebration," which targeted the entire city and included children and adults among rich, middle-class and poor families. On December 22, the city selected Public Square as the display site of the largest Christmas tree ever seen in Cleveland up to that point. Decorated with toys and trimmings, two thousand red and green electric light bulbs and a blazing star at its top, the tree rose to a height of sixty feet. Cleveland partially paid for the tree

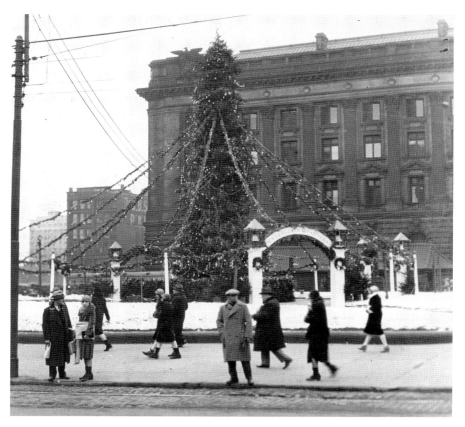

The 1927 Public Square Christmas tree appeared in a rather austere backdrop when compared with modern-day surroundings. *Courtesy of Cleveland Public Library, Photograph Collection.*

by issuing "Good Will Stock" at one dollar per share. Purchasers received a red and green stock certificate that featured drawings of Santa Claus, Moses Cleaveland, a Christmas tree and a branch of holly. The stocks' promised dividends included witnessing children's happy voices and smiles. John D. Rockefeller bought one hundred shares, as did Millionaires' Row resident Francis Drury. Leonard Hanna, another wealthy Euclid Avenue resident, purchased fifty shares.

The merriment's noise level turned up a notch in 1924, when, for the first time, microphones amplified a Christmas Eve concert on Public Square. At midnight, bells resonated from the Old Stone Church to herald the arrival of Christmas Day. Six trumpeters perched at the top of the old Illuminating Company Building next to the church concluded the fifteen-minute

celebration to welcome Christmas. Radio station WTAM transmitted the festivities to Clevelanders who owned radios.

In the dreary 1930s, when Cleveland lacked the funds to stage elaborate holiday celebrations, civic organizations contributed the money needed to stage the Public Square lighting ceremonies. Mandated blackouts during World War II ended the modest Public Square outdoor lighting display. Automobile gas rationing restrained travel, while the rationing of meat, sugar and butter inhibited the preparation of elaborate holiday dinners. Immediately after the war, striking coal miners created shortages that further inhibited lighting.

The year 1934 marked the first *Cleveland Press* Christmas Parade. The two-mile pageant, which began on Euclid Avenue at East Twenty-First Street, traveled to Public Square and then down Superior Avenue to East Sixth Street before terminating at Rockwell Avenue. Children and adults cheered on floats, high school marching bands, majorettes, jugglers and clowns. The newspaper first staged the annual parades on Friday evenings but later

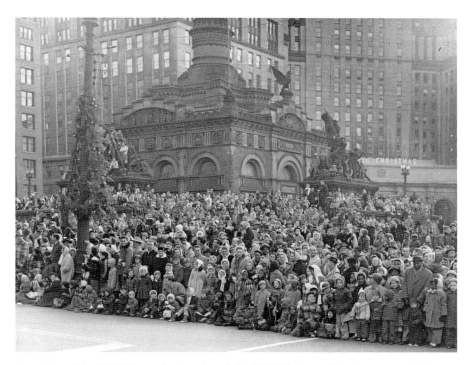

A portion of the 175,000 people who viewed the 1957 Christmas Parade were packed near the Soldiers' and Sailors' Monument on Public Square. *Courtesy of Cleveland Public Library, Photograph Collection.*

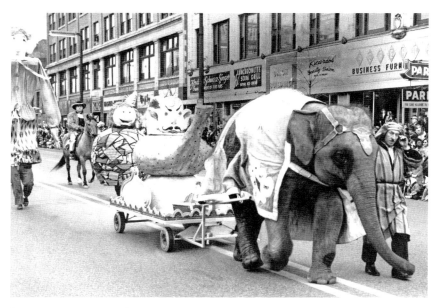

In 1963, as temperatures hovered near freezing, an elephant strolled down Euclid Avenue. *Courtesy of the Cleveland Press Collection, Michael Schwartz Library, Cleveland State University.*

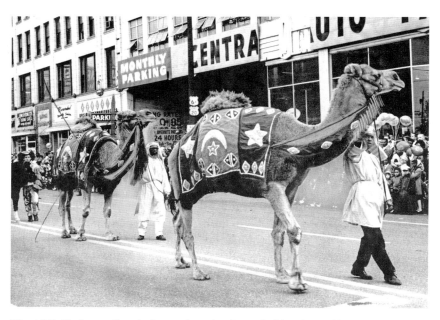

The 1969 Christmas Parade featured a pair of camels. Two dozen Siberian Huskies also marched along the parade route. *Courtesy of the Cleveland Press Collection, Michael Schwartz Library, Cleveland State University.*

adopted Sunday afternoon. Through the decades, the processions increased in extravagance with the inclusion of live elephants and camels. Viewers marveled at giant balloons depicting Aladdin and his magic lamp, a forty-foot-long dragon and two-story-high pigs, bears, walruses and panthers. Parade participants included stagecoaches, a pipe-smoking octopus and Keystone Kops pedaling an 1870 velocipede. The *Cleveland Press* continued its sponsorship of the parades through 1967.

The May Company and radio station WIXY (1260 AM) sponsored the parades from 1968 to 1975. Believing the floats, marching bands and cheerleaders needed assistance attracting people from the suburbs, promoters during this era recruited popular entertainers as parade marshals and participants. This list of entertainers included a young Michael Jackson with the Jackson Five, Paul Anka, Bobby Vee, James Darren, the Four Tops, Osmond Brothers, Temptations and Lettermen, Tim Conway, Partridge Family cast members (David Cassidy, Susan Dey and Danny Bonaduce) and Harlem Globetrotters star Meadowlark Lemon.

The parades showcased bigger and more dramatic floats, which included a sixty-five-foot lion, a forty-foot whale, a white bear as large as a house, a

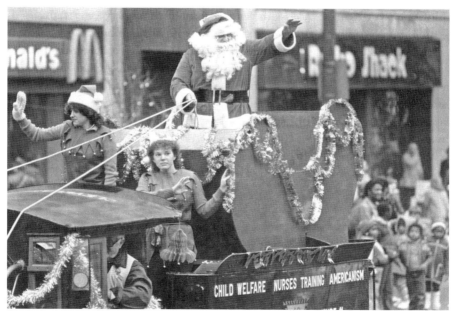

Following ten years of inactivity, the Christmas Parade resumed in 1985, cosponsored by WJW Channel 8 and the American Legion. *Courtesy of Cleveland Public Library, Photograph Collection.*

block-long dragon, a 150-foot-tall balloon that depicted St. George, Disney personalities and the Illuminating Company's prominent mascot, Reddy Kilowatt. Cleveland State University's accounting department created a float that resembled an adding machine; students marched behind the float wearing cardboard characterizations of erasers and pencils. In 1972, the parade moved from Sunday afternoon to Thanksgiving Day.

The city of Cleveland sponsored the 1976 parade after the May Company and WIXY discontinued their patronage. No further major parades occurred until 1985, when WJW (Channel 8) and the American Legion supplied the sponsorship. Local celebrities who acted as parade marshals included Michael Stanley, Drew Carey, Bernie Kosar and Mike and Sharon Hargrove. Beginning in 2002, the parades funded by KeyBank and the American Legion featured singer and nightclub star Tom Jones and championship skater Rosalyn Summers as grand marshals. The pageants ended as the downtown Winterfest developed into the major focus of the city's holiday activities.

Violence exploded on Christmas Eve 1937, as holiday merrymakers thronged Euclid Avenue. A man possessing a long record of criminal activity in Los Angeles; Chicago; Washington, D.C.; and other cities attempted to rob a Fanny Farmer candy shop just west of the Taylor department store. He fired at a police detective who was stationed in the store, but his gun jammed. The detective then shot and killed the robber.

In the 1950s, civic groups used Public Square to assemble for both secular and sacred tributes to the Christmas holiday. A twenty-four-foot-tall bell on Public Square honored Cleveland's public-school children, while a twenty-foot-tall cross lauded the city's Catholic students. The Cleveland Church Foundation installed a huge replica of a Bible in front of a church window. The Foundation of Catholic Women's Clubs mounted a nativity scene, which was accompanied by a flock of twenty-four real sheep attended by a shepherd. The city also displayed fifteen twelve-foot Christmas trees, each decorated by a different nationality group. The Cleveland Board of Education added a Bethlehem scene; the Catholic Board of Education constructed a rose window; and the Lutheran Center erected a replica of the city's first Christmas tree.

Popular singer and bandleader Vaughn Monroe (an Akron native) appeared on Public Square for four years (1954 to 1957) and sang "Silent Night," "The First Noel" and the Italian carol "Gesu Bambino" accompanied by the fifty-two-member Higbee Company Choral Club. He then sang Christmas carols for three additional years under the giant

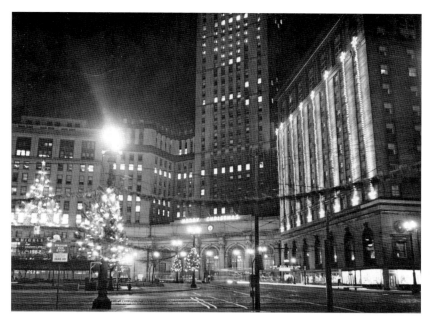

Public Square's Higbee Company (*left*), Terminal Tower (*center*) and Hotel Cleveland (*right*) brightened a 1952 holiday evening in downtown Cleveland. *Courtesy of Cleveland Public Library, Photograph Collection.*

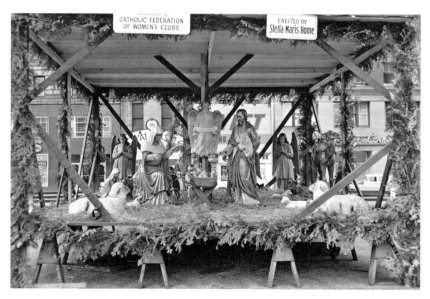

Nativity scenes, such as the one in this 1957 image, inspired Christmas cheer on Public Square for many holiday seasons. *Courtesy of Cleveland Public Library, Photograph Collection.*

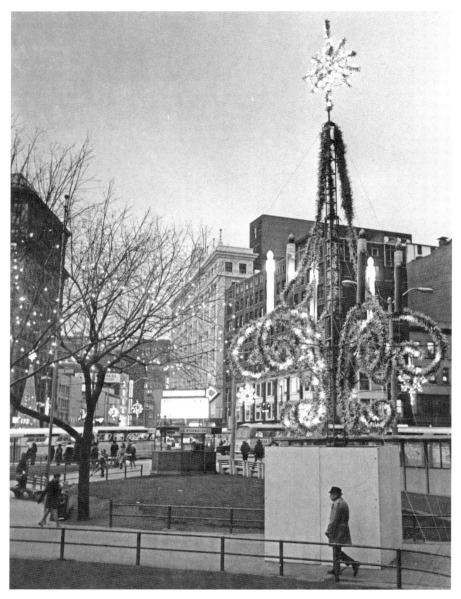

Above: This swirly 1975 Public Square decoration characterized the quirky depictions that were very common in the 1970s. *Courtesy of Cleveland Public Library, Photograph Collection.*

Opposite: In 1946, a Christmas tree with an elaborate village and fancy backdrop decorated the interior of a Goodwalt Avenue home located north of Detroit Avenue, near West Seventy-Fourth Street. *Courtesy of Cleveland Public Library, Photograph Collection.*

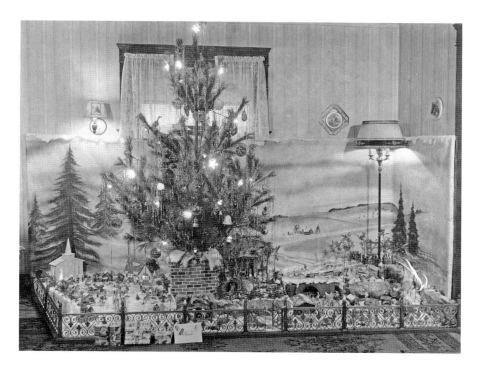

Sterling-Lindner-Davis Christmas tree assisted by seventy-five members of the St. James' Boys Choir of Lakewood. During this period, Monroe actively promoted Christmas seals.

Mitch Miller (of *Sing Along with Mitch* fame) joined radio personalities Bill Randle and Carl Reese to emcee twelve hours of continuous recorded Christmas music selected from new Columbia record albums recorded by Johnny Mathis, Ray Conniff, Andre Kostelanetz and Arthur Godfrey, along with a new *Sing Along with Mitch* Christmas album. Today, Public Square continues to be a focal point of Christmas celebrations, as it hosts the city's annual Winterfest extravaganza, complete with a holiday tree lighting, ice skating and entertainment.

During the twentieth century, Cleveland's Christmas celebrations did not always emulate Norman Rockwell's idealistic illustrations. Steel mills and oil refineries didn't stop production on Sundays or holidays—not even on Christmas Eve and Christmas Day. Police officers, firefighters, hospital employees and bus and streetcar drivers often worked on the holidays, as did many employees of restaurants, hotels, theaters and other service businesses. Family gatherings, which sometimes resulted in liberal liquor and beer consumption, created rowdy environments that even included

bloody fistfights inspired by everything from questioning the faithfulness of a friend's wife to doubting the expected winner of the Cleveland Browns' then-annual championship football appearance that took place on Sunday afternoons during the holiday season.

In 1961, Santa Claus presented Stephanie and Diana, both two years old, with balloons and presents wrapped in colorful paper and tied with ribbons. Both girls grabbed at the balloons and expressed surprise when an unexpected popping noise led to the balloons' speedy disappearance. Undaunted, the two reached for more balloons but in a much more careful manner. The two then recklessly ripped off the wrapping paper, at times using their teeth to cut the ribbons. After viewing the presents, the pair engaged in a tug of war to determine which would claim the doll they both coveted. Except for displaying more vigor, Cleveland Zoo researchers decided the two chimpanzees didn't act too differently from their own children.

Taking advantage of a higher-than-normal forty-six-degree temperature and no precipitation, one of the largest crowds in downtown Cleveland's history jammed into the city on November 25, 1962 (the Sunday following Thanksgiving). About 300,000 people viewed the annual Christmas parade, while 53,601 Cleveland Browns fans celebrated an early Christmas present when the home team defeated the rival Pittsburgh Steelers. Public Hall reached its visitor capacity shortly after its 9:00 a.m. opening as a NASA Science Fair fascinated 44,750 people that day. The lighting decorations in Public Square attracted thousands more, while downtown movie theaters drew solid attendance for *The Longest Day*, *Whatever Happened to Baby Jane?*, *Girls! Girls! Girls!*, *Period of Adjustment*, *The Best of Cinerama* and *The War Lover*. Even after adjusting for multiple events, about 350,000 people enjoyed the downtown festivities. Automobile traffic slowed to a standstill, while long delays occurred at bus stops and rapid transit stations. A fire in the Buckeye Building on East Fourth Street destroyed its top floor and contributed to the overall congestion.

Not everyone expressed pleasure in the blatant merchandising of Christmas. In 1969, fifteen local ministers and priests founded an organization that was dedicated to deemphasizing the extreme commercialism associated with the holiday. The group suggested that no more than $2.50 should be spent on a Christmas gift. They suggested that any excess money could be contributed to their organization or a group helping to support poor people. The clergymen also advocated abolishing Christmas cards and expressed strong anti–Santa Claus sentiments. Their proposals failed to elicit mainstream support.

By 1970, downtown Cleveland was suffering from urban blight, civic sadness and violent crime. The Playhouse Square movie theaters had closed and nearby restaurants followed. Merchandise replaced the former creative Christmas display windows at the May Company. In November 1971, *Plain Dealer* columnist George Condon described Public Square as "the seediest public center in the United States." Within one month of his editorial, horrified children waiting in line to visit Santa Claus at the Higbee store witnessed a father die after suffering seven stab wounds to his heart and lungs during an altercation with another dad. Across Ontario Avenue, a second death occurred that season when a suspected shoplifter shot and killed a May Company store detective.

On December 27, 1972, in a real-life blend of an old-fashioned Wild West movie and a modern action thriller, a sixteen-year-old boy attempted to rob an East Fourth Street jewelry store. After the young thief pulled a gun from his briefcase, the store owner smashed his fist through a display window, scaring the criminal out of the store. Two security guards and a Cleveland policeman chased the youth down a crowded Euclid Avenue, which was filled with workers on their lunch hour break. As he passed the Hippodrome Theater, the robber fired a shot and grabbed a pedestrian as a hostage. Near East Ninth Street, two waiting police officers killed the robber with shots to his head. In and out of juvenile detention institutions nearly his entire life, the young robber incurred his first arrest at the age of eight for stealing a bicycle. At the time of the Cleveland altercation, a Columbus correctional institution had granted him a temporary release to visit his family during the Christmas holiday. A school bus driver and auto worker gained new leases on life after receiving the dead teenager's kidneys.

In 1977, the city added eighty-five extra downtown police officers not to direct crowds but to protect shoppers from pickpockets, robbers and other criminals. As they strolled through downtown streets, policewomen posed as vulnerable Christmas shoppers with carelessly held packages and purses within easy reach of a lawbreaker. Two policemen were assigned to each decoy to observe suspicious-looking pedestrians. Following eighty-four arrests in the first thirteen days, many remaining criminals moved off the streets and into the department stores, but the police followed their lead and oversaw even more arrests.

During the 1970s holiday seasons, the dreary downtown still managed a few light-hearted surprises. The Higbee Company delivered a few minutes of unusual entertainment one morning by unintentionally leaving their outside loud speakers on while employees received a pep talk before the store's

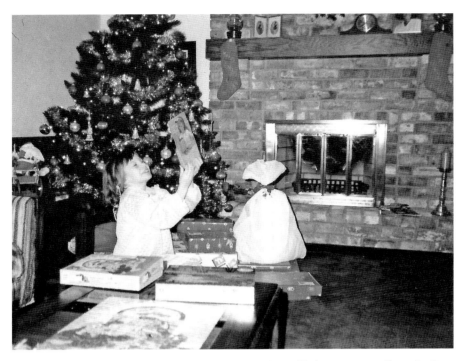

In the mid-1980s, the joy of receiving a cherished doll as a Christmas present lit up the face of this seven-year-old girl. *Courtesy of the author.*

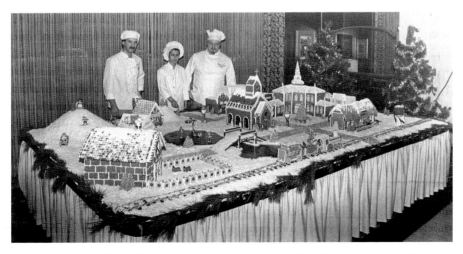

In 1985, the Bond Court Hotel displayed the restaurant staff's edible gingerbread village, which was constructed from 200 pounds of gingerbread, 60 pounds of coconut snow and 150 pounds of powdered sugar. *Courtesy of Cleveland Public Library, Photograph Collection.*

opening. A glimpse of Hollywood glamor occurred in 1979, when movie star Natalie Wood participated in the filming of the made-for-television film *The Cracker Factory*. Wood walked down Euclid Avenue, passing the Fanny Farmer candy store, before pausing at the May Company entrance. In her second scene, she stood on the steps of the Old Stone Church.

Elaborate Christmas Day dinner buffets at Stouffer's Inn on the Square attracted large crowds in the 1980s. In 1985, adults paid $14.95 and children $7.95 for roast turkey, sugar-glazed ham, prime rib au jus, salads, side dishes, bread and butter and treats from a Viennese desert table.

Cleveland's stunning twenty-first-century downtown revival, which has featured a rebuilt Public Square, reconfigured and renovated theaters, a growing residential population and a resurgence of restaurants and entertainment offerings, has sparked new interest in the Winterfest holiday celebrations and the city in general.

Lighting Up Cleveland

Since 1929, a trio of stunning Christmas lighting events have enthralled Clevelanders during almost every holiday season. The city initiated the merriment on Public Square in 1913. A dozen years later, General Electric's Nela Park launched its cherished lighting spectaculars. In 1929, Shaker Square debuted its Christmas exhibitions that *Life* magazine featured in an article underscoring Christmas lighting across the country twenty years later. In addition to these notable celebrations, owners of downtown buildings, neighborhood shopping districts and residential homes have originated even more holiday lighting gaiety.

Inhibited by the Great Depression, World War II and a coal industry strike, Public Square's annual lighting ceremony languished during the 1930s and 1940s. But in 1950, the city promoted its largest illumination spectacle to date by employing twenty-five thousand lights to brighten sixty trees. The illumination doubled in quantity in just six years; by 1964, Clevelanders were thrilled by viewing seventy-five thousand lights. Today, Public Square exhibitions employ about five hundred thousand lights.

Celebrities added star power to the lighting ceremonies when, in 1959, stage, screen and television star Miriam Hopkins (appearing at the Hanna Theater in *Look Homeward Angel*) supplied the signal to brighten Public Square. The next year, Johnny Mathis (who also performed at the Hanna) triggered the beautification. In 1965, mathematical wizard Dr. Frank Ryan, who was the quarterback of the Cleveland Browns National Football League championship team the previous year, tossed toy footballs into a Public

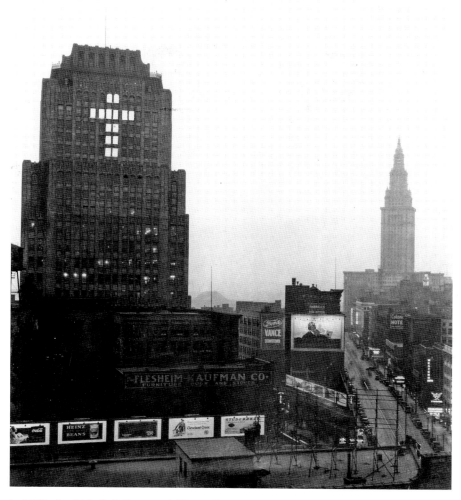

In 1928, the Ohio Bell Company's Huron Road building comprised the setting for a five-story Christian cross. *Courtesy of Cleveland Public Library, Photograph Collection.*

Square crowd to signal the activation of the Christmas lights. Ryan told the crowd he wanted Santa Claus to bring another football championship to Cleveland, but his wish has yet to be fulfilled.

Two children earned the honor of assisting Mayor George Voinovich in switching on the 1988 lights after they submitted letters requesting a chance to participate in the ceremony. Emcee Larry Morrow asked nine-year-old Julie from Strongsville what she wrote, but Julie didn't quite remember. When

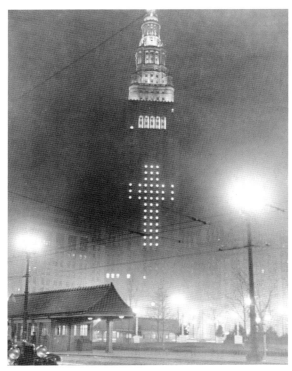

Left: Beginning in 1938, the Terminal Tower displayed a 160-foot-high by 80-foot-wide red Christian cross that was created by lighting fifty-one windows on the building's twelfth through twenty-fourth floors. The cross remained during the holiday season into the 1960s. This image is from 1938. *Courtesy of the Cleveland Press Collection, Michael Schwartz Library, Cleveland State University.*

Below: Cleveland's Christmas lighting hasn't been confined to buildings and trees. In this 1949 image, two decorated sixty-foot-long freighters are docked at the East Ninth-Street Pier. *Courtesy of Cleveland Public Library, Photograph Collection.*

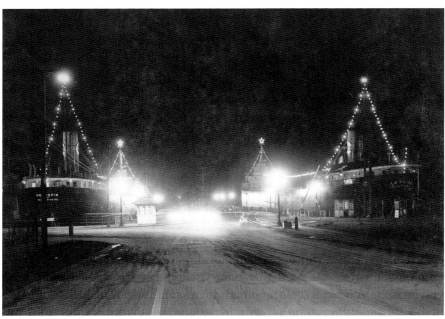

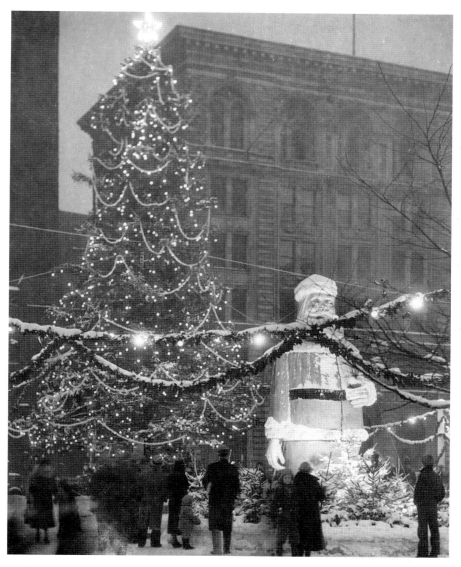

Looking north, a Christmas tree and Santa Claus brighten Public Square in 1934. Today, the chamber of commerce building, located in the background of this photograph, is the site of the 888-foot-tall KeyCorp Building. *Courtesy of Cleveland Public Library, Photograph Collection.*

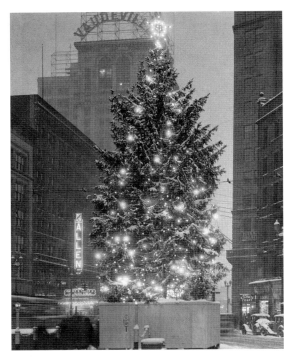

Left: Christmas tree lights combined with glittering movie theater marquees to illuminate Cleveland's Playhouse Square district in 1934. Around the corner, George M. Cohan appeared in person at the Hanna Theater during the week of Christmas. *Courtesy of Cleveland Public Library, Photograph Collection.*

Below: A brightly lit Public Square in 1966 attracted thousands of visitors on foot and in automobiles. *Courtesy of Cleveland Public Library, Photograph Collection.*

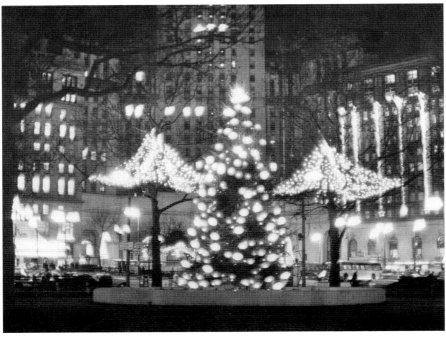

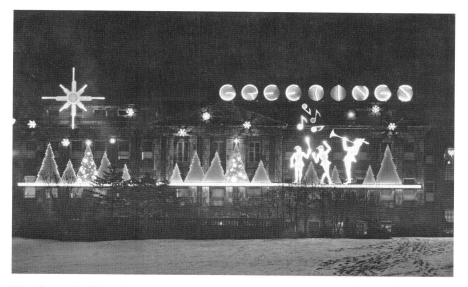

Musicians, colorful musical notes and a huge "greeting" highlighted one of the 1935 Nela Park displays. *Courtesy of Cleveland Public Library, Photograph Collection.*

Morrow posed the same question to ten-year-old Michael from Lakewood, he claimed he didn't remember either but provided further explanatory information: "My grandmother wrote it for me." Legendary congresswoman Mary Rose Oaker, who was present at the ceremony, suggested bringing his grandma up to the stage to discuss the letter's content.

In 1992, while singing "It's Beginning to Look a Lot Like Christmas," Santa shot fireballs across Public Square; each caused a different section of the square to burst into colorful light. Today, the spectacular display, which is composed of about a half a million lights, is accompanied by fireworks and pyrotechnics.

In 1913, the National Electric Lamp Association (NELA), a consortium of incandescent lamp manufacturers, constructed what is regarded as the world's first industrial park, a ninety-two-acre facility on Noble Road in East Cleveland. Primarily sponsored by General Electric from its inception, the company acquired the facility when the association disbanded. Through the years, Nela Park developed floodlights for the Statue of Liberty, multi-vapor lamps for illuminating sporting events and many lighting innovations.

Nela Park initiated its famous holiday lighting extravaganzas in 1925. The *Plain Dealer* described the inaugural display as including "every form of illuminated Christmas decoration—beacons, illuminated trees, signs

of greeting, glowing stars, festoons and streamers." In the 1930s, the park displayed an astonishing one-hundred-foot-tall, blue-lit "Star of Wonder," which weighed nearly a ton.

In 1940, General Electric linked the lighting display to the poem "A Visit from St. Nicholas" (more commonly known as "'Twas the Night Before Christmas"). Elves turned the pages of a huge book containing the poem, while displays featured a mouse resting near an enormous slice of cheese and Santa riding across a sky illuminated with the message "Merry Christmas to All." War blackouts and postwar coal shortages preempted the display from 1942 to 1948. A sixty-foot tree highlighted its return in 1949.

During the 1950s, Nela Park dazzled visitors with lighting displays built around carefully crafted themes. In 1952, "Through the Pages of a Christmas Album" presented holiday scenes from 1878, 1903 and 1928. "Santa Claus Is Coming to Town," the 1953 topic, featured seventy-foot-tall candy canes and a forest of Christmas trees. In 1954, "An Album of Christmas Songs" showcased displays inspired by "Winter Wonderland," "Santa Claus Is Coming to Town," "Oh, Little Town of Bethlehem," "Silent Night," "White Christmas" and "Auld Lang Syne." The 1956 extravaganza, "The Greatest Story Ever Told in Light," included the tallest human-constructed Christmas tree in the world—a one-hundred-foot-tall steel pole with attached branches and 5,500 lights. The 1957 display, "Joy to the World," was comprised of 7,000 lights and giant illuminated toys, along with music and animation.

In 1958, extreme traffic congestion within the complex forced Nela Park to limit displays to the six-block section of Noble Road outside of the facility. Two years later, the East Cleveland Police Department could no longer handle the massive holiday traffic. General Electric consequently divided its spectacular display among the company's six Northeast Ohio facilities (Noble Road in East Cleveland, East 152nd Street in Cleveland, Ivanhoe Road in Cleveland, Tungsten Road in Euclid, Highland Road in Richmond Heights and Campbell Road in Willoughby). During the 1960s, the fragmented approach resulted in individual displays far less exciting than the former unified versions.

In 1972, the lighting display returned exclusively to Nela Park. "Christmas Candies," the 1989 display, featured a fifty-foot-tall candy cane and elves manning a candy factory with a forklift truck, dump truck, tractor, conveyor and wagons. Highlights of the "Light Christmas" theme in 1990 included a nine-foot-tall fiber-optically illuminated peacock, a landscaped garden with a river and fountain of light, an Alpine scene with skiers making downhill runs and Santa traveling in a hot-air balloon,

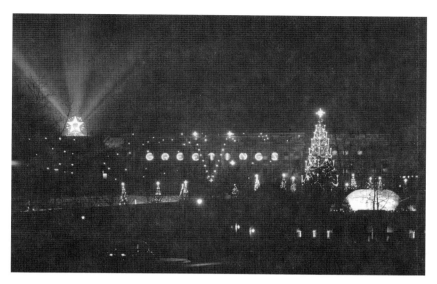

Hampered by war restrictions and postwar coal shortages, this image depicts one of only three Neal Park exhibitions presented in the 1940s. *Courtesy of Cleveland Public Library, Photograph Collection.*

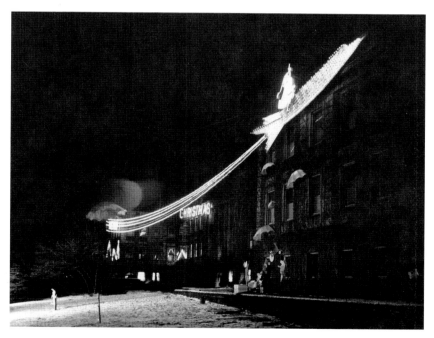

The 1954 edition of the Nela Park Christmas lighting display presented futuristic scenes with rocket ships. *Courtesy of Cleveland Public Library, Photograph Collection.*

Nela Park's 1980 lighting exhibit centered on a "Christmas Wonderland" theme. *Courtesy of Cleveland Public Library, Photograph Collection.*

airplane and rocket. "The Battle of the Mouse King" and a 160-foot-long dragon highlighted a 1995 *Nutcracker* display. In 1999, the "Holiday Songbook" was composed of displays based on the refrains from "Silver Bells," "Up on the Housetop" and "Frosty the Snowman."

In the twenty-first century, the 2003 "Traditions in Lights" recaptured some of the most popular scenes from past displays. Although Nela Park had been using low-wattage bulbs since 1981, the conversion to LED lighting in 2010 saved about 90 percent of the electricity consumption. The 2015 offering paid tribute to well-known Cleveland landmarks, such as the Rock and Roll Hall of Fame, Playhouse Square, Cleveland Museum of Art, Euclid Beach and the Metroparks. Nela Park created another "greatest hits" spectacle in 2017, this time showcasing popular displays from the past nine decades, all re-created using LED lights. Also in 2017, General Electric revived the former custom of allowing automobiles within the facility but terminated the policy after one year for same reason that caused its abandonment in 1958: the traffic problems could not be effectively handled. In addition to

its annual Cleveland lighting display, Nela Park has acted as a consultant for lighting the national Christmas tree in Washington, D.C., since 1963.

Celebrating its very first Christmas in 1929, Shaker Square's lighting exhibition featured a pair of giant Christmas trees, electric stars shining from the tops of buildings and four thousand lights covering nearby structures and store windows. In the early days, lighting ceremonies attracted about four hundred people. By the end of the 1930s, two massive candles, throwing long streams of light across storefronts and buildings, joined the twin tress as signature holiday attractions. War restrictions and coal shortages prevented the lighting for six years during the 1940s.

In 1952, fireworks and seventy-five trees, in addition to the now-iconic pair of giant trees, added to the holiday excitement. By 1955, the number of spectators viewing the holiday lighting had increased to eight thousand. In 1962, the display encompassed twenty-six thousand lights, eight twenty-two-foot-tall angels and eight candles, the largest thirty-five feet high, along with the customary tall trees and numerous smaller varieties. The energy crisis of the 1970s preempted the lighting for four years. Beginning again in 1977, Shaker Square has continued to be a source of entertainment throughout every Christmas season.

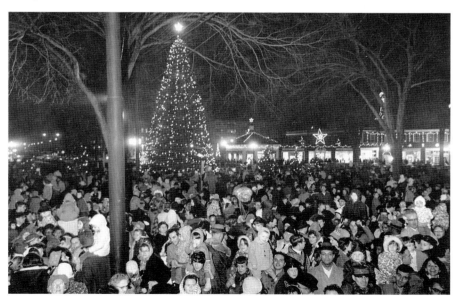

By 1965, the Shaker Square lighting ceremony attracted thousands of holiday celebrators. *Courtesy of the Cleveland Press Collection, Michael Schwartz Library, Cleveland State University.*

In 1939, a home decorating contest inspired the owners of a Schaff Road residence to create this display. *Courtesy of Cleveland Public Library, Photograph Collection.*

In 1927, the *Plain Dealer* created a Greater Cleveland residential lighting contest that inspired interest in lighting and decorating the exteriors and yards of homes. Judges awarded eight prizes totaling $225. A Cleveland official commented, "The response has been so great Santa Claus can drive a sextet of blind reindeer from Rocky River to Painesville [on] Christmas Eve and not be obliged to ask one policeman for directions." To assist contestants in their decorating, the *Plain Dealer* suggested reading two books: *Christmas Outdoor Decoration*, which was available through the Electrical League of Cleveland, and *Yuletide Lighting*, a Nela Park publication. The newspaper even offered its own advice regarding how to favorably impress the judges. The first suggestion seemed rather obvious: position the interior Christmas tree near the window so judges can see it from the street. Another recommendation involved decorating windows with wreaths beautified with either electric candles or red and green lights. Outside the home, the *Plain Dealer* advocated for colored lights decorating the porch, the eaves of the home and the flower boxes, along with placing

luminated Christmas bells over entrances and windows. In the yard, chances of winning the contest were enhanced by running lights through trees and shrubbery, placing lighted natural or artificial Christmas trees on the lawn and lining the driveway with lights.

Miss Viola Pritchard, who lived at 2118 Taylor Road in Cleveland Heights, won first prize in the first competition. In 1928, the popularity of the annual contest inspired the *Plain Dealer* to modify the rules and award a total of $400 in prize money among two categories: five or more pieces of material (wreaths, strings of lights, et cetera) and less than five pieces. By 1930, the contest had expanded to a total of fifty prizes totaling to $1,250. After dividing Northeast Ohio into five geographical areas, each area incurred a division into homes valued at or above $15,000 and $15,000 and below. Judges awarded a full set of five prizes within each of the ten subcategories.

To avoid an unfair advantage over the general public, several thousand members of the Cleveland-based Electric League created their own contest. In the 1950s and 1960s, the league expanded its sponsorship to national residential events, offering portable automatic electric dishwashers and electric percolators as prizes. As the decades progressed, individual

By 1961, residential decorating had increased in complexity, as evidenced by this West Fifty-Seventh Street home. *Courtesy of Cleveland Public Library, Photograph Collection.*

neighborhoods, suburbs, chambers of commerce, garden clubs and other groups created their own competitions. In one of those events, the Pritchard family on Taylor Road won the top prize a second time. Homeowners in many neighborhoods continue the decorating custom today by creating elaborate displays in their homes and yards.

Christmas Tree Tales

The early Christian Church exhibited no interest in Christmas trees, since pagans had used fir trees for centuries in late-December rituals. A legend traces the Christmas tree's origin to Saint Boniface, a Benedictine monk. In 723 CE, Boniface supposedly witnessed a pagan winter sacrifice that took place in front of a gigantic oak tree dedicated to Thor, a god of strength symbolized on Earth by thunder, lightning and stately trees. Horrified by the ritual (some versions of the legend depict the sacrifice of a very young boy), Boniface chopped down the oak with one powerful swing of an axe. When he suffered no adverse consequences—not even crashes of thunder or bolts of lightning initiated by Thor—Boniface proclaimed the Christian God far superior to Thor. The legend concludes with a young fir tree springing up from the roots of the old oak, thereby inspiring Saint Boniface to designate fir trees as holy.

Decorated indoor Christmas trees have been traced back to 1605 in Strasbourg, Germany. German immigrants later introduced the trees to the United States in the mid-nineteenth century. August Imgard, one of the earliest American Christmas tree proponents, cut down a blue spruce near his Wooster, Ohio home in 1847. He decorated the tree with nuts, popped corn, cranberries, paper ornaments and candy canes and positioned a metal star at its top. Placing the tree on a slowly revolving platform in his window, Imgard's creation attracted curious visitors from miles around his home.

Reverend Heinrich Christian Schwan is often credited with lighting and displaying the first Christmas tree in an American church, although many

historians have disputed this claim. In 1851, Reverend Schwan placed a Christmas tree in the Zion Lutheran Church located at East Sixth Street and Lakeside Avenue, the current site of Public Hall. The pastor and his wife decorated the tree with bright red and green ribbons, tinsel, cookies, fancy nuts, lighted candles and a silver star that Schwan had brought from Germany when he immigrated to the United States just three months earlier. To Reverend Schwan's surprise, many congregants took offense to the display of a Christmas tree in the church; one congregant even referred to the thirty-two-year-old Reverend Schwan as a "foreigner bringing his devilish customs into our country." Another parishioner labeled the tree "a plain case of idolatry that should not be tolerated."

Local newspapers didn't help the minister's cause. The *Cleveland Leader* called the tree "a nonsensical, asinine, moronic absurdity, besides being silly." The *Leader* recommended boycotting any business that approved of the church's actions. Reverend Schwan devoted the following year to explaining to his congregation, the news media and other influential people that the Christmas tree had no connection to pagan rituals. No problems occurred the following season when he placed another tree in the church sanctuary. Within five years, Christmas trees were common in homes, churches and businesses. Any lingering objections had vanished by the end of the Civil War. In 1951, a civic group planted a fir tree at Reverend Schwan's Lake View Cemetery grave site to commemorate the one hundredth anniversary of the introduction of a Christmas tree in an American church. It is possible that some infinitesimal opposition to Christmas trees still persisted (perhaps even dating back to Thor), since the tree promptly died.

Following the Civil War, Clevelanders decorated Christmas trees with holly, miniature lanterns, globes, wax candles and glass balls. Throughout the city's streets, energetic boys engaged in thriving holiday businesses by peddling candles, gaudy tinsel ornaments, wreaths and cloth banners proclaiming, "Merry Christmas."

Prior to the twentieth century, most Clevelanders drove horses and buggies to Public Square to select their Christmas trees; some grocery stores offered a more limited selection. In 1880, three-foot-tall trees cost fifty cents, while twenty-foot-tall trees were sold for $4.00. In 1911, the West Side Market joined downtown as a popular place to purchase holiday trees.

The use of electric lights as holiday decorations began in 1880, when Thomas Edison strung light bulbs around his office. Two years later, Edward Johnson, a colleague of Edison, displayed eighty red, white and blue bulbs on a Christmas tree in his New York City apartment (along with

two additional strings of twenty-eight lights mounted from the ceiling). At the time, only wealthy people could afford the luxury of electric lights on Christmas trees. In 1900, Edison offered lighting systems and bulbs for rent during the holiday season, but the idea didn't excite the general public. Three years later, the first commercially available and affordable strings of electric lights debuted, with twenty-four bulbs being sold for $12.00 or rented for $1.50. By 1914, the Erner Electric Company on Euclid Avenue touted safer, cleaner and prettier electric lights ($2.10 per set), when compared with "old-fashioned candles."

In the early 1920s, the Higbee Company asked $3.75 for eight "beautiful pine cone lamps in red, blue, green, purple, frosted and clear." A careful shopper could have obtained the exact same item on a two-day sale at the downtown Newman-Stearn store for about half the cost ($1.85). As the years passed, the expense of tree lighting continued to decline. By 1929, the Higbeee Company advertised strings of "eight gaily colored bulbs" for seventy-nine cents. In 1935, KW Drugstores quoted thirty-three cents for eight-bulb strings and three to five cents for replacements.

As Christmas trees in the 1940s erupted into flames, consumers questioned the inherent safety of electric lights. In a home on Valleyview Avenue, near West 168th Street, a tree caught fire and, in the process of toppling over, set a piano, sofa and rug ablaze. A Lawnview Avenue resident suffered second-degree burns when the tree he had just finished decorating burst into flames. In these and many other instances in Cleveland and throughout the country, short circuits in the wiring of the lights caused the fires. By 1951, the technical problem had been solved. The May Company promoted "Safe-T-Socket" tree lights, which were guaranteed to be shockproof, waterproof, rustproof and short-circuit safe.

An annoying feature of electric tree lights persisted throughout most of the 1940s; when a single bulb burned out, the entire string stopped working. Each bulb required testing until the discovery and replacement of the culprit. In 1948, the Higbee Company promoted strings of lights ($3.75 each) in which bulbs operated independently, thus making the defective bulb much easier to locate and replace. In addition, eight movable sockets allowed lights to be placed anywhere on the twelve-foot cord. Up to seventeen extra sockets (each costing thirty-five cents) could be placed on the same cord. Retailers advertised the lights as "so excitingly new they're like magic."

By 1956, the distinctions between lights and ornaments had been blurred. The Halle department store's Trim-A-Tree Shop promoted a collection of ten lighted decorations, including a golden drum ($3.98), venetian lantern

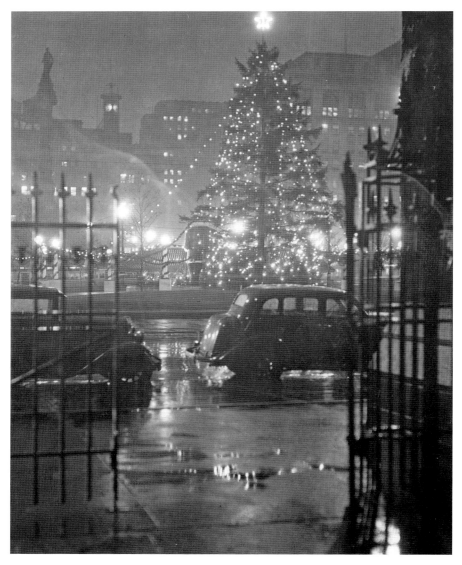

Above: A brightly lit Public Square Christmas tree in 1936 provided a brief respite from the drudgery created by the Great Depression. *Courtesy of Cleveland Public Library, Photograph Collection.*

Opposite: In the 1940s, poorly shaped branches created large bare spots on live Christmas trees. Decorations consisted mainly of very basic lights, glass balls and tinsel, and the presents underneath the trees rested on white bedsheets that conveyed a suggestion of snow. This nine-month-old girl in 1943 didn't seem to mind the absence of a spectacular setting. *Courtesy of the author.*

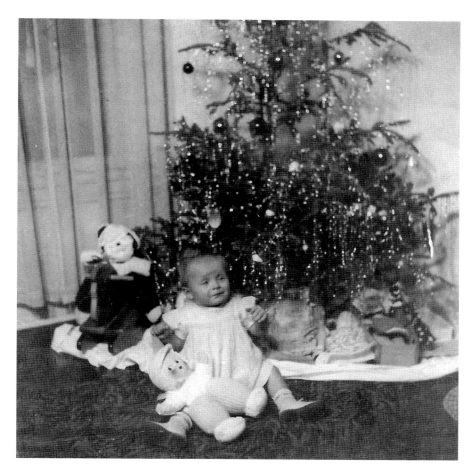

($3.98) and cherubs ($4.98). The store also stocked another innovation, General Electric timers ($12.98), which were used to turn lights and appliances on and off automatically; the device proved to be very convenient for lighting Christmas trees. In the mid-1950s, Sterling-Lindner-Davis marketed strings of twenty miniature lights (very popular at the time) for $1.98 each. The May Company priced Christmas tree ornaments imported from Germany at $1.00 for a box of twelve. The store charged $5.98 for ten-piece nativity sets with handmade figures.

In addition to its residents, the city of Cleveland also embraced Christmas trees as an integral part of the holiday season. A century after the city displayed its first "official" Christmas tree in 1913, a blue spruce of the same sixty-foot height, now draped with 56,000 LED lights, brightened Public Square, while another 372,000 LED lights in the vicinity added to the gaiety

of Cleveland's annual Winterfest celebration. Between Cleveland's 1913 and 2013 festivities, downtown Christmas trees soared to lofty heights and tumbled, for a time, to disheartened lows.

In 1929, the city lacked funds to even afford a tree. Within three hours of the announcement of the tree's cancelation, three organizations, the three Cleveland RKO theaters (Palace, Hippodrome and Keith's 105th Street), the Cities Services Oil Company and the Cleveland Florist Club (representing 250 city florists), offered to pay the entire cost of purchasing and erecting the downtown tree. The city eventually selected the Lewis and Valentine nursery to supply a live tree free of cost. As the depression worsened, Cleveland accepted gifts of trees from the Cleveland Civic Board and the I.J. Fox Fur Company.

Beginning in 1934, the May Company assumed responsibility for securing, purchasing, delivering and disposing of the annual trees. Transporting the trees proved daunting at times. In 1936, a seventy-five-foot-tall evergreen weighing six tons caused havoc on every street it traveled during its journey from a farm near Elyria to Public Square. The removal of a similarly sized Christmas tree in 1937 created a heartbreaking tragedy, when, without warning, the tree toppled. A May Company carpenter who was unfastening the wires that were holding the tree plunged sixty-five-feet to the sidewalk and died after fracturing his skull. The May Company continued its tree sponsorship for decades, except during the blackout years of World War II.

In the 1920s, an environmentally conscious movement questioned the residential, civic and business practice of killing trees to serve as Christmas decorations. A *Plain Dealer* editorial headline from December 21, 1924, pleaded, "Don't Slaughter Christmas Trees." The commentary lamented, "Men with axes have gone into the spruce, hemlock and pine forests and ruthlessly cut down the young trees without thought of conservation of our natural resources." Three years later, Cleveland's Park Director bemoaned, "It's a shame to cut down a big tree just for a week's or ten day's pleasure." The development of Christmas tree farms, which were in business expressly to grow holiday trees, partially mitigated the conservation issue, since the farms did not reside in natural forests or woods. The debate also generated expanded interest in artificial trees.

In the United States, artificial trees actually predated the use of real trees. The German Moravian church in Pennsylvania constructed candle-lit wooden trees as far back as 1747. The artificial variety became commercially available in the United States during the very early twentieth century. Hostesses of fashionable Christmas parties favored trees constructed from

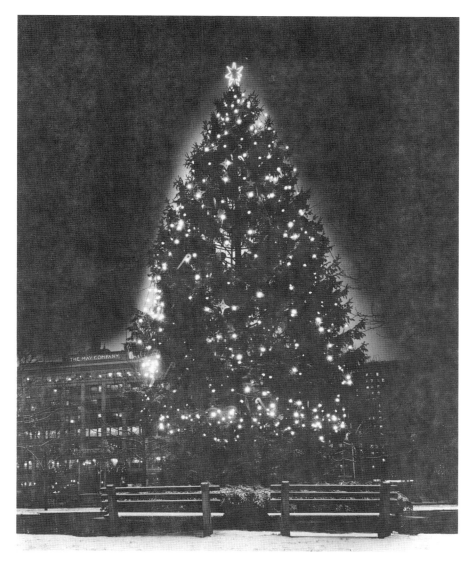

Public Square's 1946 Christmas tree decorated the area in front of the May Company department store. *Courtesy of Cleveland Public Library, Photograph Collection.*

colored ostrich feathers. In this period, artificial trees were created using feathers, papier mâché, metal, glass and various types of plastic.

In 1925, the May Company responded to the environmental movement by selling "natural-green" artificial trees, equipped with a white enamel base, for between $1.00 and $35.00, depending on the size. Three years later, the

store charged $5.75 for a five-and-a-half-foot-tall artificial tree composed of fifty branches. In the 1930s, machine-manufactured trees using green-dyed brush bristles enjoyed a degree of popularity, partly because of their advertised advantage of not being flammable. By 1952, consumers were purchasing artificial trees constructed from felt, heavy paper, plastic, wire, thin strips of metal, rope, burlap, wood, glass and cloth. The trees' heights ranged from a few inches to fifty inches, while their colors extended from realistic to fanciful.

In 1956, the Halle department store offered a "realistic looking" six-foot-tall artificial Scotch pine with 183 tapered branches ($29.95). Twenty years later, Kmart marketed a six-foot-tall Scotch pine ($14.88) that was so lifelike "it looks like nature's own." But realism wasn't always in style. During the late 1950s, the beatnik movement and the psychedelic sixties, trendy artificial trees intentionally bore little resemblance to the nature-grown variety. A silver aluminum variation, composed of no lights and limited ornaments, required a revolving lighted color wheel, situated near the tree, to systematically change the tree's color from silver to red, green, blue and yellow (or even stranger color combinations). In 1960, the May Company offered aluminum trees in six sizes, ranging from two to eight feet in height and selling for between $1.95 and $20.95. An optional four-color wheel cost $7.95.

By the mid-1960s, artificial trees encompassed about 30 percent of the total United States Christmas tree market. Returning to realism, J.C. Penny stores advertised six-foot-tall Scotch pine trees "made of green plastic yet looking so lifelike" for $9.88 in 1972. In 1980, Uncle Bill's advertised seven-foot-tall Scotch Pines containing fifty-nine branches for $34.99. A decade later, artificial trees decorated more than half of America's homes.

Although thousands of Christmas trees annually enliven holiday spirits in Cleveland homes, businesses, shopping malls and churches, from 1928 to 1967, one magical set of trees uniquely captured the imagination of Clevelanders and visitors to the city. For forty years, Cleveland Christmas holidays and the Sterling & Welch department store (and its successors) remained resolutely entwined. The store displayed its first large Christmas tree, which was fifty-five feet tall, in the store's dramatic eighty-foot-high setting known as the light court. Recognizing a unique marketing opportunity, the company acquired even larger trees each season and prominently promoted the super-sized trees in their newspaper advertising. Ranging between forty and fifty feet in height during the Sterling & Welch era, the tree's fame extended well beyond the city. In 1936, Sterling received

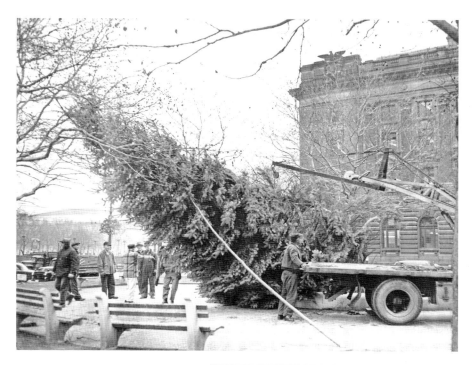

Above: In 1959, a seventy-five-foot-tall evergreen, weighing six tons, sat ready for placement on Public Square. Transporting the tree from a farm near Elyria to downtown Cleveland created havoc on virtually every street. *Courtesy of Cleveland Public Library, Photograph Collection.*

Right: In 1963, a lighting display on the not-yet-completed Erieview Tower depicted a prominent eight-story-tall Christian cross superimposed on a nineteen-story-tall Christmas tree in the background, while a thirty-six-foot-tall Santa stood in the foreground. *Courtesy of the Cleveland Press Collection, Michael Schwartz Library, Cleveland State University.*

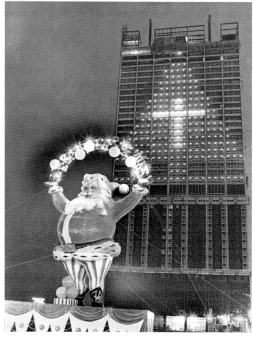

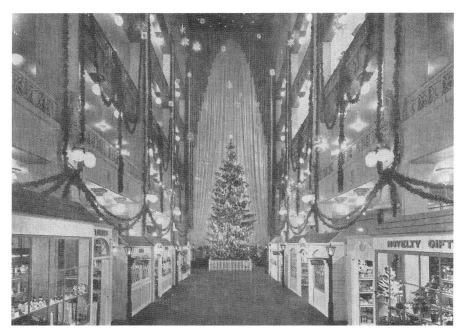

Above: Visitors who desired a closer look at the huge Sterling & Welch Christmas tree entered a "conveniently located" display area filled with gifts that were available for purchase. *Courtesy of the author.*

Opposite: Sterling & Welch described their 1938 holiday tree as "a towering symbol of yuletide spirit which rises majestically in the Great Court." *Courtesy of Cleveland Public Library, Photograph Collection.*

a letter from a New York City businessman visiting Cleveland. Praising the city, the visitor observed, "Having been in eleven states in the past few days, I compliment your city on having the most beautiful Christmas tree in any city I have visited."

Exploiting the attention generated by their annual tree, Sterling & Welch created "an avenue of evergreens" leading to the "house of a thousand gifts," a display situated near the tree that included merchandise selected from all of the store's departments. Cognizant of the depressed economic period in the 1930s, one area displayed gifts that did not exceed $10.00; examples included toasters ($1.95), waffle irons ($3.50) and Chinese embroidered silk mats in a variety of sizes that cost between $0.25 cents and $10.00. This less-expensive merchandise purposely appealed to a variety of demographic groups, including wealthier customers who spent $6.00 on silver-plated ashtrays (promoted as cigarette urns) and $10.00 on silver cocktail shakers.

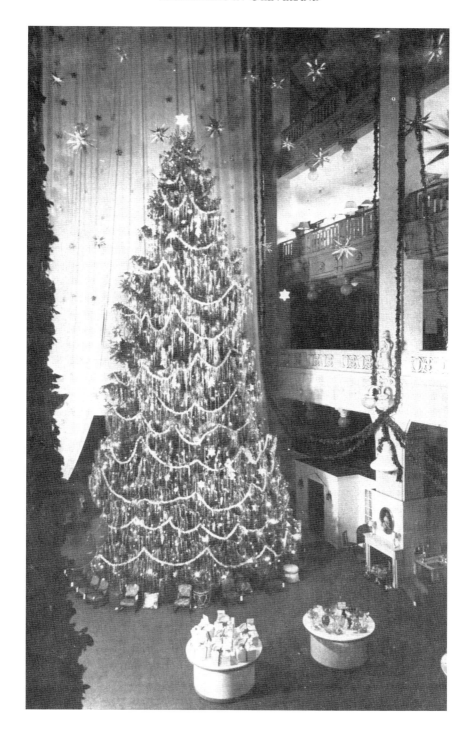

Placed in the vicinity of the $10.00-or-less merchandise, a set of twelve crystal highball glasses commanded $21.00, while a musical cigarette box that played "Anchors Aweigh" was being sold for $17.00. Expenditures for Christmas presents rose sharply during World War II; Sterling & Welch marketed a globe in a Viking oak stand ($104.00) and a General Electric sunlamp complete with an automatic timer ($39.95).

By the mid-1950s, the Sterling-Lindner-Davis Company (which was created by a series of mergers) procured even larger trees, soaring fifty to sixty feet in height. A typical tree consumed fifty gallons of water each day and grew about two to five inches during its monthlong stay in the department store. Six large spotlights placed in the surrounding galleries provided the tree's illumination, since fire dangers precluded the placement of lights on the tree. In 1959, celebrity star power added to the tree's appeal, as actress Lauren Bacall (who appeared at the Hanna Theater in *Goodbye Charlie*) turned the switch to illuminate a sixty-foot-tall tree that was promoted as "America's biggest indoor Christmas tree," and vocalist Vaughn Monroe sang carols in front of the tree. The following year, Hollywood producer Joe Pasternak and three of his budding stars autographed pictures and promoted Christmas Seals next to the Sterling tree. Twenty-four days later and a mere two blocks east of the store, the trio (Paula Prentiss, Jim Hutton and Maggie Pierce) appeared together in Loew's State Theater's Christmas movie attraction *Where the Boys Are*.

In 1964, the department store displayed its largest tree, a seventy-six-foot-tall, seven-ton Norway Spruce that was delivered from Garrettsville, Ohio. Decorating the tree necessitated seventy-five pounds of icicles, 1,500 yards of tinsel and 2,500 ornaments. In 1965, five hundred thousand people from twenty-two states viewed a sixty-five-foot-tall tree that was procured from Chagrin Falls.

Securing, delivering, installing, decorating and eventually removing the Sterling trees required precise planning and exceptional execution. After combing the area for a suitable tree and negotiating an aggregable price, landscapers dug out the tree and wrapped its roots in burlap. Whether acquired from a wooded area near Ravenna, a farm in Bath or a hillside in Kane, Pennsylvania, the tree would arrive at Sterling's front door within an hour after the store's closing on the Saturday after Thanksgiving. While Euclid Avenue remained detoured, workers removed six two-hundred-pound plate-glass doors from the store's entrance. Volunteers transported the tree from a flatbed truck into the store through the entrance and onto a four-ton ball of earth that was needed to support the tree. Decorating

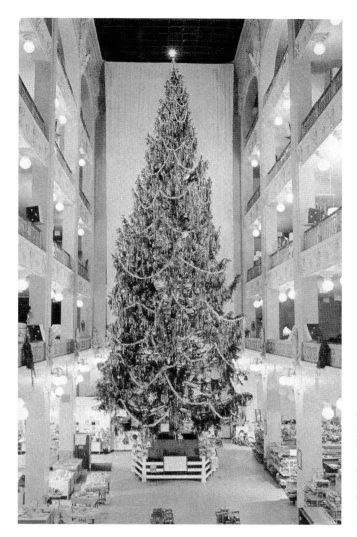

Through the years, Sterling & Welch and its successor, Sterling-Lindner-Davis, created numerous postcard images of their celebrated Christmas trees. *Courtesy of the author.*

occurred on Sunday while the store remained closed. Ornaments, some of them larger than bowling balls, reflected the immense size of the tree. When the holiday season ended, the tree's limbs were chopped off and its trunk was cut to facilitate removal and disposal.

The Sterling Christmas tree era ended in 1967, the final holiday season prior to the department store's closing. Twenty years later, a visitor to the city recalled viewing a movie newsreel of the Sterling tree while stationed in Germany. Even today, vivid memories of the mammoth trees remain in the minds of Clevelanders who are old enough to recall the 1960s or earlier.

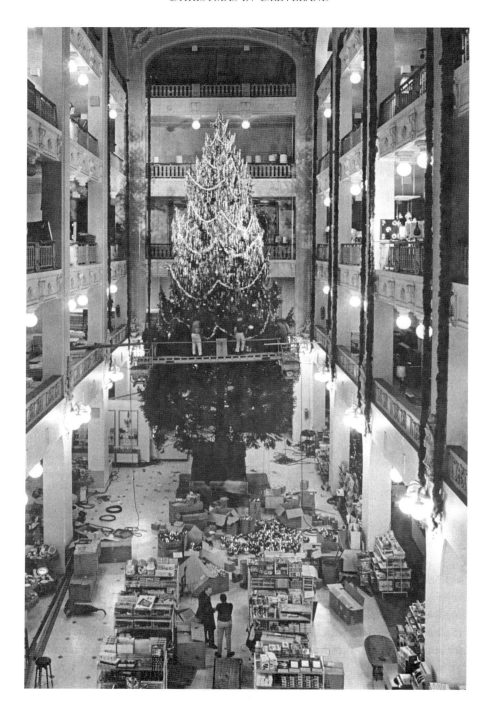

Opposite: Working on scaffolds, volunteers decorated the 1967 Sterling tree, as usual, from the top down. Although it was not known at the time, this was the final year the gigantic tree would be decorated. The department store closed prior to the next holiday season. *Courtesy of Cleveland Public Library, Photograph Collection.*

Above: Haig Avedision displayed a few of the Sterling tree ornaments he used to decorate his Euclid Avenue rug shop following the closure of the Sterling-Lindner Davis department store. *Courtesy of Cleveland Public Library, Photograph Collection.*

Following Sterling's closure and the speedy demolition of the building, a few efforts to keep the tradition alive were met with only limited success. During the holiday season following the department store's demise, a forty-five-foot spruce adorned the site of the former building. A decade later, at 1:00 a.m. in a small park that now occupies the location, workers dropped off a twenty-foot-tall Norway spruce for decorating later that morning. When the crew arrived at 7:00 a.m., the tree had disappeared, never to be recovered.

Haig Avedision had operated an oriental rug franchise in the Sterling store for twenty-one years. After the store was shut down, he opened an oriental rug shop in the nearby former F.W. Woolworth Building. For a number of holiday seasons, Avedision displayed fifteen-to-twenty-foot-tall blue spruce trees to decorate the store. The ornaments comprised one hundred former Sterling tree decorations (including eight one-foot-diameter balls that were manufactured in Vienna) that he had purchased when the store closed.

Sporadic efforts to revive the Sterling legend continued into the next generation. In 1967, National City Bank used two hundred dolls to trim their tree in the downtown bank lobby. The Old Arcade (that connected Euclid and Superior Avenues) and the Skylight Concourse of the Union Terminal utilized forty-foot-tall blue spruce trees to decorate their interiors. The new East Ninth Street Galleria (1987) introduced a sixty-foot-tall

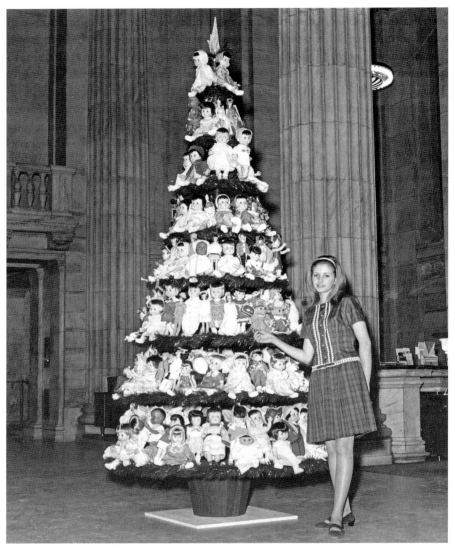

Above: In 1967, employees of National City Bank donated two hundred of their own dolls to decorate a Christmas tree situated in the bank's downtown lobby. *Courtesy of Cleveland Public Library, Photograph Collection.*

Opposite: In 1978, a large Christmas tree stood prominently in the Old Arcade. *Courtesy of the Cleveland Press Collection, Michael Schwartz Library, Cleveland State University.*

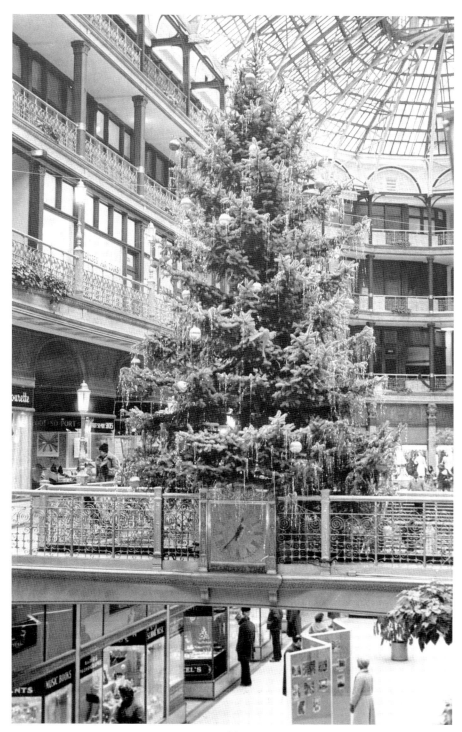

Left: In the 1980s, large Christmas trees greeted visitors as they entered the Terminal Tower through the Euclid Avenue entrance. *Courtesy of Cleveland Public Library, Photograph Collection.*

Right: The East Ninth Street Galleria shopping mall displayed a huge artificial Christmas tree for more than two decades. *Courtesy of the author.*

artificial tree with thousands of lights and animated ornaments that were highlighted by wooden rocking horses and bears playing drums. In 1996, the tree was redesigned with ornaments reflecting the early post–World War II era. Although it was tall enough in height, the Galleria tree never captured the magic of the old Sterling trees. The ornaments weren't large enough to reflect the scale of the tree's size, and an artificial tree didn't stir the imagination of those recalling the former department store's trees. Today, the magnificent Sterling trees survive only in memories and photographs.

4

Santa Claus

Although Santa Claus's current name, physical appearance and mode of travel are United States creations, his oldest known relative dates back about 1,800 years. Sometime in the third century, a real St. Nicholas resided in what is now a part of Turkey. Legends claim he gave away his entire inherited wealth to travel the country and help the poor and sick. His generosity even provided a dowry for three indigent sisters to prevent their sale into slavery or prostitution by their father. Centuries later, during the Renaissance period, St. Nicholas reigned as the most popular saint in Europe. Even during the Protestant Reformation, a period that discouraged the veneration of saints, St. Nicholas still maintained a positive reputation, especially in Holland. The name Santa Claus evolved from Saint Nicholas's Dutch nickname, Sinter Klaas.

In 1809, Washington Irving helped popularize Sinter Klaas stories when he referred to St. Nicholas as the patron saint of New York in his book *The History of New York*. Although it was written satirically, Irving's book created interest in elves. As his prominence grew, Sinter Klaas gained a reputation for being everything from a mischief maker that wore a blue three-cornered hat, a red waistcoat and yellow stockings to a man clad in short breeches and a broad-brimmed hat.

The vivid description of Saint Nick in the poem "A Visit from St. Nicholas" (which was also known as "Twas the Night Before Christmas") created a very American image of the future Santa Claus. Clement Clarke Moore, an Episcopal minister and professor of divinity and Oriental and

Greek literature in New York, composed the poem in 1822 to entertain his three daughters. Published anonymously the following year, Moore chose not to take credit for the work due to its frivolous nature. Yet children never seemed to tire of hearing the tale of an elf with cheeks like roses and a nose like a cherry. Saint Nick traveling from house to house in a miniature sleigh guided by eight tiny reindeer further enhanced the poem's popularity. Best of all, St. Nick brought Christmas presents for good little girls and boys.

In 1881, political cartoonist Thomas Nast crafted the first likeness that matched the current image of Santa Claus. Nast's cartoon, which appeared in *Harper's Weekly*, depicted Santa as a cheerful man who sported a full white beard, dressed in a bright-red suit trimmed with white fur, carried a big sack filled with toys and, in today's vernacular, was exceedingly weight-challenged.

Before children visited Santa in department stores, their communication with him had developed through the mail. The first known image of a United States mailbox used to send a letter to Santa appeared in *Harper's Weekly* magazine in 1879. In those days, letter writing often involved two-way communication between children and Santa. After possibly naïve little boys and girls relayed their Christmas wishes to the jolly elf, the kids received return letters, allegedly from Santa, warning them that continued poor behavior (the details often known only to their mothers and Santa) might reduce the number of Christmas presents delivered. Rather than jolly, these letters portrayed Santa as a stern disciplinary figure. The mention of naughty children receiving coal as a present emerged during this period, although coal would probably have been considered an improvement over eighteenth-century threats in Zurich, where mischievous children might expect horse manure for Christmas. Near the turn of the twentieth century, the Cleveland Post Office discarded letters with undeliverable addresses, such as "Santa" or "the North Pole." Soon after, the post office dispensed mail intended for Santa to charitable organizations that attempted to honor as many gift requests as possible. Depending on the amount of resources available, the practice has continued sporadically through the decades.

Hull & Dutton, one of Cleveland's first retail establishments to encourage children's visits with Santa Claus, created an 1891 advertisement that featured a playful telegram, purportedly sent by St. Nick: "I am en route to your city and will make my headquarters in your north display window from this afternoon until after Christmas. Haven't time to wire the boys and girls. Tell them." Also that year, Santa incurred a mishap, creating

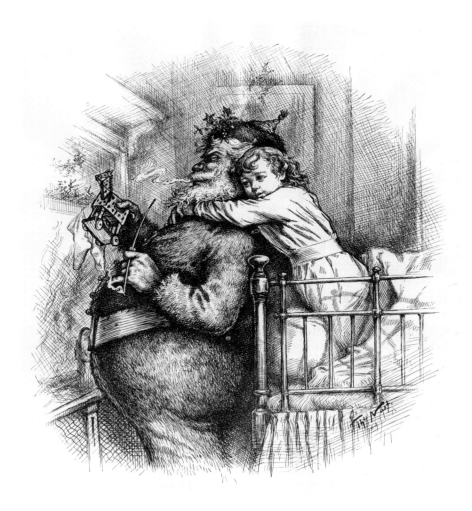

Thomas Nast's 1881 drawing portrayed Santa Claus as the jolly character that is now associated with Santa in the United States. *Courtesy of Cleveland Public Library, Photograph Collection.*

unexpected excitement at the Scoville Avenue English Lutheran Church during an evening of holiday entertainment. Ignited by candles on the church's Christmas tree, Santa's coat caught fire. Fortunately, he escaped with only minor burns.

While Santa helped cheer others in need, he also dealt with his own personal issues, especially on Christmas Eve. In 1903, Anthony Kelley fell off a Woodland Avenue streetcar. After receiving care at St. Vincent

Dear Santa Claus
Dear Santa Claus
I would like to have
an air rifel thats huts
B.B shot.
 And some shot.

Good By yours truly
 By willie Millard
no 24 ocean st
City of Cleveland. O.

 Be sure

Left: Willie Millard, in an 1898 undeliverable letter to Santa, asked for an air rifle that shot BB pellets and ammunition to accompany it. *Courtesy of Cleveland Public Library and the* Plain Dealer.

Below: Sadie Robinson's 1898 requests to Santa included a doll cradle, rocking chair and table, along with brushes and a comb for her dolly and a storybook for herself. *Courtesy of Cleveland Public Library and the* Plain Dealer.

Opposite: This late Victorian-era postcard depicts Santa accompanied by two young girls who might have emerged as flappers in the 1920s. *Courtesy of the author*.

Sadie Robinson
I wont a Doll cardle
and a rocking chir
and a tale and a
Story book and
Some Side come and a
dittel brois and come
for my Dolly.
to Santa Calus

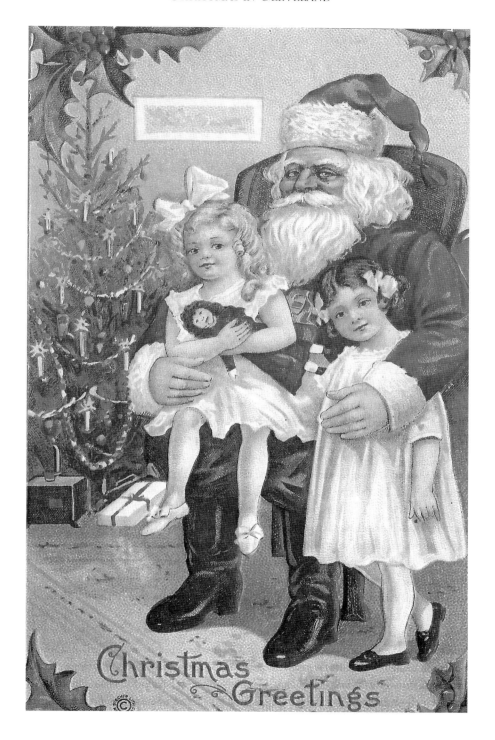

Hospital, Kelley identified himself as Santa Claus and demanded to be released because he had work to do that evening. Taken to the police station, authorities charged Kelley with intoxication; he remained in jail until Christmas morning. In 1909, a court granted the wife of a department store Santa a divorce and custody of their children. In 1928, an apologetic Santa, who was arrested for drunkenness, provided this job-related explanation: "I caught a cold walking up and down the streets with a sign on my back telling folks where to buy their kiddies toys. I took several drinks to cure my cold. I guess they went to my head and made me drunk." On Christmas Eve in 1933, an employee of a restaurant located at East Seventeenth Street and Superior Avenue telephoned the police with this message: "Santa Claus is here, and he's tight. He's full of the old Nick. You better come and get him."

Clevelanders have had the opportunity to view Santa in a wide variety of sizes. In 1930, Loew's State Theater's lobby laid claim to the world's largest Santa Claus, which was thirty feet tall and nine feet wide. Eight years later, "Kute Kris Kringle," whom showman Mike Todd advertised as "a real human who is only three inches tall," busily worked constructing toys in a doll-like cottage while touring the downtown RKO Palace Theater and Warner Brothers' Colony, Uptown and Variety Theaters. Children communicated with the tiny Santa using a miniature telephone.

By the 1930s, conversing with Santa in person had developed into an enormously popular ritual. On the Friday after Thanksgiving in 1931, about forty thousand children visited Santa in Cleveland's downtown department stores. During most of the year, these elves toiled at other jobs; two of them worked in the same department store, one was an executive and the other was a night watchman. Other Santas included a business owner, furnace salesman, magician and truant officer.

In the 1930s and 1940s, the various Santa Clauses employed in Cleveland's retail stores enjoyed meeting together in their "Santa Claus Club." Attending an annual party at the Hotel Statler, the group exchanged stories, many relating to the Christmas requests from their visitors. One Santa confessed he didn't know how to respond to a little girl who asked for "a pair of pink panties for my Mommy." Another Santa thought twice after a girl requested new poker chips for Daddy. In 1946, an inquisitive and imaginative young boy wished for a television "so he could see what goes on at the North Pole."

In 1942, card-carrying Santas received a Christmas present that few American workers would have expected. The War Labor Board allowed

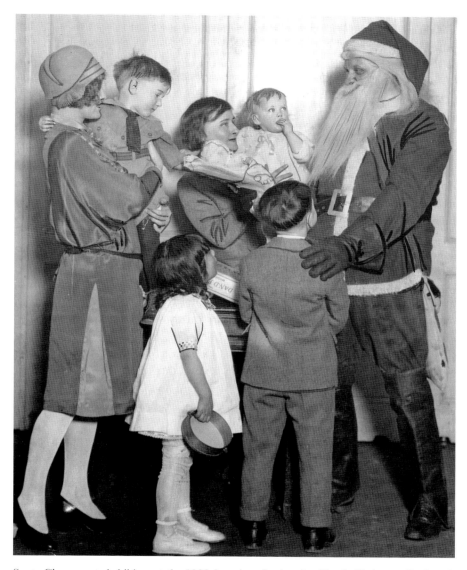

Santa Claus greeted children at the 1926 American Legion Auxiliary's Christmas Orphans' party at the Hotel Hollendan in downtown Cleveland. *Courtesy of Cleveland Public Library, Photograph Collection.*

an authentic Santa Claus to receive a pay raise, despite the country's freeze on wages. The official government ruling limited the exemption to "only such persons as wearing a red robe, white whiskers and other well-recognized accouterments befitting their station in life and provided that

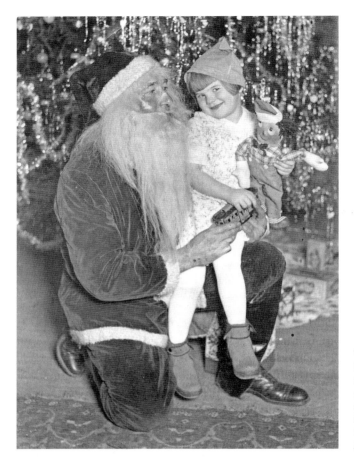

With a doll in one hand and a toy train in the other, a six-year-old girl is seated on Santa's lap in 1927. *Courtesy of Cleveland Public Library, Photograph Collection.*

this exception shall not be considered as a precedent, since the role of Santa Claus in a war-torn world is unique." In a 1944 letter to Santa, one Cleveland child poignantly requested, "Please bring my daddy home. He is somewhere in the Pacific." Another letter that year didn't ask for a gift but merely offered Santa some advice: "Don't give Billy anything because he curses."

In 1952, the Higbee Company erected a three-ton, thirty-one-foot-tall Santa Claus constructed of plaster of paris and chicken wire, which stood atop the department store's entrance for many Christmas seasons. The Fisher Foods grocery chain offered customers an opportunity to select one of its "cleverly written Santa Claus letters" to be postmarked from the post office in Santa Claus, Indiana. Also in 1952, Western Union inaugurated the Santagram, a message decorated with colored pictures of toys and

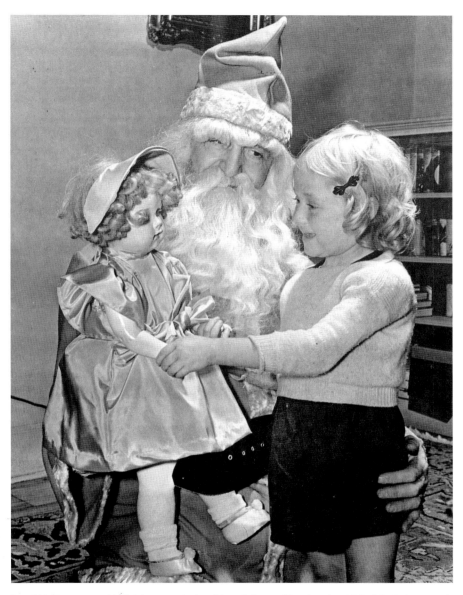

In 1939, Santa provided this young lady with a doll capable of saying "Ma-Ma." *Courtesy of Cleveland Public Library, Photograph Collection.*

supposedly delivered by the company from the North Pole prior to Santa's journey to Cleveland. Parents selected from nine messages including:

I am on my way in a sleigh, loaded with toys for good girls and boys, and especially for you. See you soon.

From the land of ice, with a pack of presents nice, my trusted deer are bringing me down. Your house will be my first stop in town.

I received your message and will bring you as many gifts as I can.

I have what you most desire. Thought I'd let you know by Western Union wire.

Not all the communication to Santa represented the desires of children. An imaginative employer seeking secretarial assistance placed this advertisement in a 1956 *Plain Dealer* classified section: "Dear Santa Claus, please send me a secretary twenty-one to thirty-five. I will pay her a very good salary and provide fine working conditions. My office is in the Union Commerce Building."

In the 1950s, Cleveland's mayors, dressed as Santa, rode in a sleigh accompanied by cardboard reindeer in the annual Christmas parade. Political leaders weren't alone in desiring Santa garments. Greater Clevelanders rented about five thousand Santa Claus outfits each year in the mid-1950s. Cotton wigs and beards, which were in need of constant cleaning and combing, gave way to rayon, a fiber that was more cost-effective to manufacture and clean.

Mr. Jingeling, Santa's most famous Cleveland assistant, debuted in 1956 at the Halle department store. His backstory (which was later developed into a thirty-minute play presented in the store) originated when Santa lost the keys to the store's seventh-floor Treasure House of Toys, thus preventing Santa from making his annual toy-distributing trip. Mr. Jingeling, an experienced locksmith, created a special key to unlock the treasures. Santa finished his deliveries on time and, in gratitude, proclaimed the locksmith the official keeper of the keys and the number-one elf helper. In a revised backstory, the key opened a treasure house located in a far-off castle rather than in the department store.

Known for his pointy-toed golden elf shoes, a green wool suit and white hair sticking up above his ears, Mr. Jingeling presented children with green-and-white cardboard keys that were to be worn around the neck

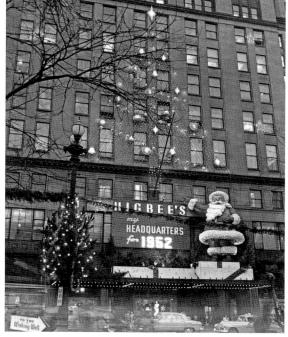

Right: A thirty-one-foot-tall Santa Claus first appeared above the Higbee Company entrance in 1952. *Courtesy of Cleveland Public Library, Photograph Collection.*

Below: Typical of children throughout Northeast Ohio in 1965, these four girls visited with Mr. Jingeling at the Halle department store. *Courtesy of Cleveland Public Library, Photograph Collection.*

and a novel pair of balloons, one imbedded inside the other. The smaller balloon contained a picture of Mr. Jingeling. An assistant elf also distributed free plastic hand puppets. The year after his first Halle Company arrival, Santa's key-making colleague initiated daily appearances on local television programs during the holiday season.

In the mid-1960s, the Halle Company created the "Mr. Jingeling Theater," which, along with color cartoons, featured the key maker telling stories and performing magic tricks. Mimicking the Halle shoppers, he also traveled to the store's suburban locations. In the early 1980s, the department store created a "Mr. Jingeling Museum," an animated gallery of childhood fantasies in the spirit of Christmas. The store even developed a musical play titled *Mr. Jingeling and the Computerized Christmas*. Unfortunately, the downtown Halle store closed soon afterward. Undaunted, the now-famous locksmith moved twelve blocks west to the Higbee department store. After its closure, he relocated to Tower City and has also participated in Public Square lighting festivals and appeared in the Fifth Street Arcades.

Through the years, the downtown stores created other interesting characters to assist Santa, none of whom garnered the sentimentality of Mr. Jingeling. In 1949, Sterling-Lindner-Davis introduced Francis the Talking Mule, a large, purple creature equipped with a sliding board stemming from his mouth that he conveniently used to send gifts to children waiting below. Each child who visited Francis received a red-and-white button that stated, "I talked to Francis, Sterling-Lindner-Davis' talking mule." Francis once admitted to reporters, "I can't count up to more than twenty-five, but it seems to me I talk with a lot of young people each day." In 1957, Sterling introduced "The Masked Wrangler," an interesting diversion for children who were waiting in line to visit Santa. Kids even sat on his $5,000 silver saddle (but without an accompanying horse). The store never provided a backstory for the mysterious wrangler, but he seemed adept at fielding questions related to bad guys, sheriffs and horses. Meanwhile, a clown named Malcolm entertained children who were waiting in line to visit Santa at the May Company. In 1973, Bruce the Talking Spruce, a large tree who enjoyed chatting with children about Christmas and its meaning, debuted at the Higbee Company. Requiring little encouragement, Bruce would also sing a song or two. The friendly tree is still a part of Cleveland's annual Winterfest celebration.

By the 1960s, many Cleveland children wrote to Santa and expressed their wishes very concisely and politely:

I already have a baby brother, so this time, I want some crayons.

I would like a microscope, and I will leave the rest up to you.

I would like a Thumbelina doll. If you don't have one, you may get me anything.

You already know what I want. I told you two weeks ago at the Giant Tiger store.

Letters to Santa often demonstrated old-fashioned kindness and concern for the ageing elf:

I will leave both plain and chocolate milk because I'm not sure which kind you prefer.

If one of your reindeers get sick, my dog will pull the sled.

Don't forget to dress warm.

I want you to have a Merry Christmas and tell all the reindeer I said hi.

I hope you are feeling well because you are going to have a big trip on the 25th.

By 1984, even a third grader grasped one of the biggest health risks facing the country. In a letter to Santa, he wrote, "If you don't stop smoking, you will not be able to deliver presents. And it will kill you, and I will be mad at you."

Little boys sometimes expressed reasonably extreme views concerning Santa's failure to deliver the presents they desired. In 1961, Santa received this complaint: "Every year, I write to you for stuff, and I never get it. I wrote to you for a submarine and a spaceship and an elephant and a pony, and did I get them? No!" Rather than composing a letter, a young lad, in 1971, decided to express his disappointment at the Halle Company Santa by kicking him in the shin. "That's for not getting me what I said I wanted!" he screamed as he quickly exited the area.

At times, downtown department stores seemed perfectly willing to share Santa with their customers. In 1968, the May Company promoted hiring Santa to visit homes for a fee of $7.50 (December 14 through 23) or $10.00 on Christmas Eve. One of Santa's occasional altercations occurred in 1968.

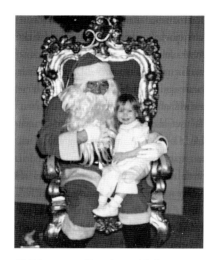

Children spending time with Santa Claus in department stores has remained a jovial ritual for more than seven generations. This image portrays an eighteen-month-old girl visiting Santa in 1980. *Courtesy of the author.*

Police arrested an intoxicated Santa Claus following a fender-bender accident at West 110th Street and Detroit Road. The driver claimed he needed to deliver Christmas presents to an orphanage that evening. When the inebriated Santa failed to produce a driver's license, he spent the night in jail. The following morning, police discovered the truth to his story and sent him on his way, a day late for his promised delivery.

In 1978, the downtown department stores still reported that children were waiting in two-hour lines to visit Santa Claus. Just a dozen years later, the May and Higbee Companies, which were then the last remaining downtown Cleveland department stores, discontinued children's visits with Santa. In 1994, the Dillard Department Store (now the owner of the former Higbee Company) revived the tradition, but the store remained in operation for only seven more years.

Although he is most often portrayed riding in a sleigh drawn by reindeer, Santa's unique modes of arrival to parties, parades and lighting ceremonies have often produced their own share of excitement. During the Great Depression, Santa showed up at both the downtown Higbee and Halle department stores following a landing at the relatively new Cleveland airport. Not to be outdone by mere airplanes, Santa reached the Taylor department store riding on the back of an inflatable whale named Bertha.

In 1939, Santa reached the Shaker Square lighting ceremony by riding in a 1914 Buick. In 1953, he appeared as a motorman driving a brand-new rapid transit car. Although it was decorated in a string of colored lights, Santa couldn't use the rapid transit's strong power to energize his lights. He toted a gasoline-driven generator to supply the small amount of electricity that was need for his own decorations. The *Plain Dealer* noted the generator solved Santa's "current" problem. In 1955, Santa disembarked from an iceberg float near another contraption carrying Kelly, a 550-pound brown bear. Santa arrived late that year because of the traffic congestion around Shaker Square. He used a rocket ship for his 1956 appearance, the Shaker

Rapid Transit in 1957 and a new Cleveland Electric Illuminating "sky-worker" truck in 1958.

For the downtown Christmas parade, Santa has arrived in a fire truck, a taxi and a double-decker bus that was later utilized to shuttle shoppers between Public Square and Playhouse Square. As suburban Christmas shopping proliferated in the 1950s, Santa devised even more ingenious methods of arrival. He descended by way of a helicopter into the parking lots of the Fairview Park shopping area and Westgate Shopping Center. From his Westgate landing, Santa rushed to the North Pole workshop, where he chatted with mall visitors using a closed-circuit television broadcast set up under a thirty-two-foot-tall replica of himself in the center of the mall. Becoming more daring, Santa valiantly parachuted 2,500 feet from an airplane, targeting his arrival for the Eastlake Mall parking lot; instead, he landed in a mud puddle in a field near the mall. Santa arrived at the Lee-Harvard Shopping Center in a simulated spaceship that weighed four tons. Another Santa, joining a Jack & Heintz Company employee party at the Cleveland Arena, showed up skating across the arena ice. In Bay Village, Santa emerged from helicopters at both the Bay Shopping Center and Cahoon Park.

Considering all of Santa's various arrivals, his 1961 appearance at a Forest City building supply store in suburban Brookpark remains the most mysterious. In fact, few people have ever learned exactly how he materialized. Tinsel, a magical clown and good friend of Santa, traveled from the North Pole to mystifyingly assist Santa in his arrival at the lumber yard. After his emergence, Tinsel continued her magic by making animals appear, disappear and reappear.

The 1990s witnessed a few cases of unusual crimes, one even involving an attack by one of Santa's elf helpers. A woman, who was not pleased with the picture that was taken of her two children on Santa Claus's knee at the Randall Park Mall in 1992, asked an attendant dressed in an elf costume if the picture could be retaken. The elf inexplicably chased the woman through the mall and then attacked her. The victim required treatment for a sprained neck. In 1993, a twelve-foot-tall plywood Santa disappeared from the front yard of a moving and storage company in Lakewood, where it had previously reigned for fifteen years during the holiday seasons. Following an extensive police search and substantial media coverage, the Santa was unexplainably returned the day before Christmas Eve—but in four pieces. Employees repaired Santa the same day so he could resume his holiday presence. In 1994, Santa and two assisting elves, all wearing ski masks, robbed

the Third Federal Savings branch in the Southland Shopping Center. As the trio exited, Santa dropped a package on the floor, which he told employees and customers contained a bomb; in reality, it more resembled a stick of dynamite. Nearly identical bank robberies had already occurred in Omaha, Kansas City, Cincinnati and Columbus. When robbing banks during the non-holiday season, the gang wore shirts with an FBI logo and escaped in getaway cars that had been obtained using the names of retired FBI agents. The robbers donated part of the stolen money to support white supremacist causes until their arrests in 1996.

The twenty-first century brought dramatic changes in the way children communicated with Santa and selected Christmas presents. By 2000, Santa (along with children's relatives and friends) checked gift requests using online Christmas gift registries established by major toy retailers. Operating handheld electronic scanners, kids swiped UPC barcodes on items they desired while wandering through toy stores. In 2003, children emailed Santa from one of Tower City's eight public computers equipped with the then-revolutionary wireless internet. Today, www.Claus.com calls itself "the merriest place in cyberspace," and www.EmailSanta.com provides pages of interesting Santa-related information, including an extensive Santa joke collection. Here's an example: "An honest politician, a kind lawyer and Santa Claus were walking down the street and saw a twenty-dollar bill. Which one picked it up and kept it? Answer: Santa Claus. The other two don't exist."

Concern for the Needy

*I*n 1900, the now-ubiquitous Salvation Army kettles and accompanying bell ringers made their first appearances in Cleveland at the Euclid Avenue entrance to the Old Arcade, in front of major downtown stores and on Public Square corners, where streetcar riders congregated while waiting for transfers. The initial year's donations of $1,742 provided Christmas dinners for the city's poorer residents. Two years later, the Volunteers of America began gathering funds to supply clothing and toys for underprivileged families.

In 1913, the management of the Hippodrome Theater invited more than one thousand orphans to enjoy a Christmas Eve matinee vaudeville performance followed by a big party arranged in the theater. After the show, orphans filled the huge stage to receive a gift—a toy for boys and a doll for girls, each accompanied by candy and an orange. Santa made a special trip to the rear of the theater to distribute gifts to orphans who were unable to walk to the stage.

Beginning in 1916, Dr. Edward Kieger, attorney Frank Voldrich and businessman Frank F. Rice delivered Christmas presents to the patients and staff of St. Alexis Hospital. The three families originally paid for the gifts; Broadway Avenue merchants and friends of the hospital later assisted in contributing funds and presents. Following Kieger's death in the hospital in 1971, his children and grandchildren continued the tradition until the hospital closed in 2003.

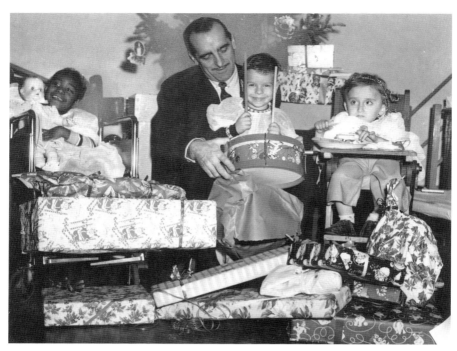

Opposite, top: A representative from a Cleveland Arthur Murray dance studio, in association with the Society for Crippled Children, distributed gifts to handicapped children in 1950. *Courtesy of Cleveland Public Library, Photograph Collection.*

Opposite, bottom: Patients at Glenville Hospital in 1961 cherished a candlelight Christmas carol concert presented by the nurses. *Courtesy of Cleveland Public Library, Photograph Collection.*

Above: The members of St. Augustine Catholic Church in Tremont exemplified concern for the needy by providing meals for the less fortunate. This image is from 1985. *Courtesy of Cleveland Public Library, Photograph Collection.*

In 1921, prior to the decade attaining its roaring reputation, Cleveland chose not to purchase a Public Square Christmas tree; instead, it used the money to help needy families cope with a severe economic downtown. The *Cleveland News* initiated its "Toy Shop" effort in 1923 to collect, renovate and distribute used toys. By the 1930s, the emphasis had shifted to providing brand-new warm clothing, toys and games. The *Cleveland News* devised novel methods to raise funds for its "Toy Shop" initiative. In 1930, city officials, judges and other prominent Clevelanders, acting as honorary members of the newspaper's Old Timers Club, hawked souvenir *Cleveland News* editions. The Cleveland Zenith Skippies, once world champions

of a bantamweight football league, donated part of their gate receipts to the "Toy Shop" cause. Two decades later, the Harlem Globetrotters and College All-Americans continued the practice during their 1950s barnstorming stops in Cleveland.

An annual boxing program, featuring featherweights, heavyweights and every classification in between, developed into a primary fundraising source for the *Cleveland News* initiative. Commencing at Public Hall in 1926, the boxing matches encompassed a creative mixture of current champions, future titleholders and aspiring local heroes. Reigning champions Phil Scott (heavyweight champ of Britain) and Solly Krieger (world middleweight titleholder) battled in the Cleveland matches. Joe Lewis and Sonny Liston both rose to become world heavyweight champions within two years of their *Cleveland News* bouts. Carmen Barth (a gold medal winner in the 1932 Olympics), Johnny Risko and Eddie Simms headed an impressive list of talented local boxers. In 1937, the fights moved to the new Cleveland

Joe Lewis stood triumphantly over Eddie Simms (Cleveland's "Slugging Slovenian") in a 1936 Christmas charity boxing bout at Cleveland Public Hall. *Courtesy of Cleveland Public Library, Photograph Collection.*

Arena, where 12,888 spectators established the then-largest audience for an indoor Ohio boxing match.

In 1932, the three daily English-language newspapers combined efforts to present a marathon ten-hour entertainment benefit at Public Hall. The festivities began at 8:00 p.m., with performances by home-grown dancers, singers and comedians. The entire cast of a Loew's State vaudeville show, starring Yiddish entertainer Molly Picon, joined the benefit after completing their Playhouse Square performances. The popular local radio team of Gene Carroll and Glen Rowell then took to the stage to initiate a radio telethon that concluded at 6:00 a.m. the following morning. The city provided free coffee and sandwiches for spectators who opted to remain after midnight. Adults paid twenty-five cents and children ten cents for the entire ten hours. Concurrent with the Public Hall benefit, about one thousand polo enthusiasts jammed the Equestrium (located at West Sixty-Eighth Street and Denison Avenue) to view three polo matches that also benefited the *Cleveland News* charity.

Employees of the *Cleveland Press* loaded a truck with food during the 1934 Christmas Fund campaign. *Courtesy of the Cleveland Press Collection, Michael Schwartz Library, Cleveland State University.*

Movie legend George Raft ordered breakfast at the Hotel Statler the morning after he emceed the 1939 Christmas charity show at Public Hall. *Courtesy of Cleveland Public Library, Photograph Collection.*

In 1935 the *Cleveland Press* initiated the first of fourteen annual charity shows designed to raise money to purchase Christmas presents for needy Cleveland children. A single stage that faced both Public Hall and the adjoining Music Hall, allowed more than fifteen thousand people, each paying twenty-five cents, to attend the benefit. Forty local amateur acts, billed as "stars of tomorrow," featured singers, impersonators, roller skaters, dancers (jitterbug, tap, ethnic and ballet) and musicians playing the piano, drums, bagpipes, clarinet and accordion. An applause meter, measuring the volume of handclapping and cheering, determined the winners. Ruth Gibson, an acrobatic dancer residing on Star Avenue (near East Eightieth Street and Superior Avenue) secured the initial one-hundred-dollar first-place prize.

Although the local talent never failed to deliver a pleasant evening of entertainment, the shows' major drawing card was the celebrity master of

ceremonies. Through the years, the superstar list included Bob Hope, Frank Sinatra, Jack Benny, Bud Abbott and Lou Costello, Danny Kaye and film stars Jimmy Stewart, George Raft, John Garfield, Errol Flynn, Pat O'Brien, Joe E. Brown, Wallace Berry, Walter Pidgeon and Jack Carson. The shows' attendance peaked at 17,024 in 1939, when George Raft was the host.

Cleveland's WEWS (television channel 5) began broadcasting on December 17, 1947, as Ohio's first commercially licensed television station and the sixteenth in the United States. The very first telecast presented coverage of the *Cleveland Press* Christmas show at Public Hall. For the benefit of the few Clevelanders who actually owned a television, the station advised viewers that WEWS could be found somewhere between 76 and 82 megacycles on their dial. Four hundred people filled the Higbee Company Auditorium to view the show on the store's five television sets. The people who watched the broadcast laughed at emcee Jimmy Stewart as he was awarded an honorary one-dollar prize for his accordion-playing skills, and

In 1947, Christmas charity show emcee James Stewart (*left*) discussed the logistics of Ohio's first television broadcast with Jack Howard (*center*), the director of Scripps-Howard Radio, and James Hanrahan (*right*), the vice president of television channel WEWS. *Courtesy of Cleveland Public Library, Photograph Collection.*

Jimmy Stewart (*top left*) rehearsed his accordion playing skills with members of the 1947 Christmas show cast. *Courtesy of the Cleveland Press Collection, Michael Schwartz Library, Cleveland State University.*

they enjoyed amateur acts that included the Hilltop Hillbillies of Heights High School. Although Clevelanders were utterly amazed at watching images transmitted through the air, Higbee customers noted that the small screen lacked precise definition and provided less-than-satisfactory sound accompaniment. Televisions in 1947 certainly didn't rival viewing movies shown in Cleveland's downtown and neighborhood theaters.

6

Sacred Stories

Revolutionary War veteran Joseph Badger, the Western Reserve's first missionary after its formal settlement, relocated from Blanford, Massachusetts, where he had directed a church for fourteen years. Arriving in 1800, he preached open-air sermons in Cleveland and Newburg (now southeast Cleveland). Based on his first two years in Northeast Ohio, Badger concluded that the pioneers "opposed piety and glorified infidelity."

Near the end of 1816, a full twenty years after Cleveland's founding, a handful of the town's 150 settlers gathered in the log cabin home of Phineas Shepherd on West Twenty-Fifth Street to organize what would become Trinity Episcopal Church. Two years later, the congregation's thirteen families symbolically represented the entire churchgoing population of Cleveland, although no actual church building had ever been constructed anywhere in the city. Controlled and administered by lay people, the congregation met in members' homes. In 1878, Reverend John W. Brown, the church's rector, told his congregation that the village in 1816 required religious influence to counteract "the violent immorality" that existed at the time. Brown continued, "Religion seems to have been the theme for mockery and coarse jesting."

In 1829, the congregation consecrated Cleveland's first church building, a small, white, wood-frame structure with green blinds located on the southeast corner of St. Clair Avenue and West Third Street. Requiring more space, the congregation erected a stone structure near the intersection of Superior Avenue and East Sixth Street in 1855. As this new church neared completion, the old St. Clair Avenue place of worship burned to the ground.

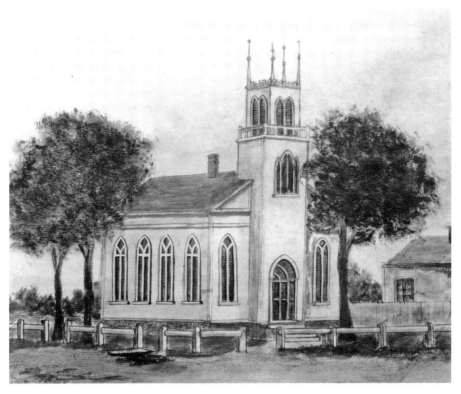

In 1829, the members of Trinity Church built their first formal place of worship on the southeast corner of St. Clair Avenue and West Third Street. *Courtesy of Cleveland Public Library, Photograph Collection.*

A newspaper account provided this highly theatrical description of the event: "As the flames devoured it, all the old settlers of Cleveland felt that an old, familiar friend was departing. But what a suitable way to depart. Lighting up the magnificent city whose progress it had looked down upon from its venerable steeple since the first dawning of a sickly village." In 1907, Trinity Church relocated again after the construction of the still-existing English Gothic cathedral on the southeast corner of Euclid Avenue and East Twenty-Second Street was completed.

On December 24, 1961, Trinity Cathedral inaugurated an annual revival of the combined medieval boar's head and Yule log celebrations. Before Christianity, Romans chose boars' heads as the first dish served at their colorful feasts. In the medieval period, the boar's head, decorated with garlands and herbs, became an important part of Christmas festivals in

In 1855, the Trinity congregation relocated to Superior Avenue near East Sixth Street, the present site of the Leader Building. *Courtesy of Cleveland Public Library, Photograph Collection.*

The magnificent Trinity Cathedral, constructed in 1907 and shown here fifty years later, is still located on Euclid Avenue at East Twenty-Second Street. *Courtesy of Cleveland Public Library, Photograph Collection.*

the great manor houses of Norman England. The Christian church added symbolic meaning to the once-pagan celebration. The boar represented evil, and its cooked head signified the triumph of Christ over sin. The Yule log, lighted from the previous year's embers, symbolized the rekindling of love with the passage of an old year and the dawn of a new one. As the centuries passed, additional secular and sacred symbols enhanced the colorfulness of the celebrations. Trinity Cathedral incorporated many of these symbols as part of their Christmas season celebrations. More than one hundred authentically costumed participants represented Good King Wenceslas and his pages, wise men, shepherds, British knights, Tower of London beefeaters,

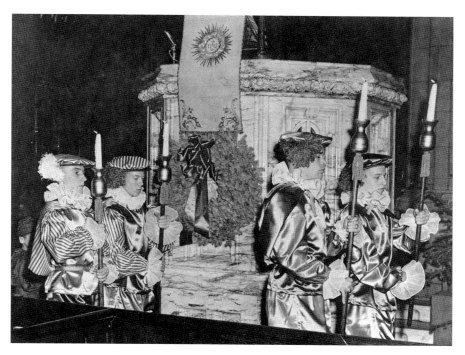

Above: Trinity Cathedral's combined Boar's Head and Yule Log celebrations are annual reenactments of old medieval customs. This image depicts a scene from the 1963 presentation. *Courtesy of Cleveland Public Library, Photograph Collection.*

Right: Constructed in 1855, the First Presbyterian (Old Stone) Church has survived two major fires. This image is from 1920. *Courtesy of Cleveland Public Library, Photograph Collection.*

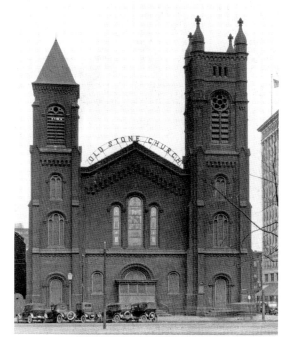

Elizabethan jesters and singers, woodsmen and hunters, all accompanied by a real roasted boar's head and a thirty-pound mince pie.

In 1820, sixteen Clevelanders organized the First Presbyterian Church, Cleveland's second major place of worship. The congregation worshiped in an old log courthouse on Public Square prior to their 1834 erection of a gray sandstone building nicknamed the "Stone Church." Since many later churches used stone in their construction, the First Presbyterian Church became the "Old Stone Church." In 1855, the need for additional worship space necessitated a larger church; it was also built from stone and located on the same site. Two years later, the interior required reconstruction following a serious fire. Then, in 1884, a much more damaging inferno spread from a next-door theater. The following morning, in temporary quarters, the pastor preached a sermon titled "Thou Knowest Not what a Day may Bring Forth." Architect Charles Schweinfurth remodeled the interior, reinforced and rebuilt the exterior and roof, and in the process, he turned the church into a much more elaborate and appealing place of worship. The work represented his first major assignment in Cleveland. Schweinfurth later designed Trinity Cathedral, Calvary Presbyterian Church, the Church of the Covenant, the Union Club, the Florence Harkness Memorial Chapel, numerous Euclid Avenue "Millionaires' Row" homes and architecturally significant stone bridges over Martin Luther King Boulevard.

A native of Toronto, Dr. Robert B. Whyte served in two Canadian churches before he became the pastor of the First Presbyterian Church of Philadelphia from 1923 to 1935. He arrived at the Old Stone Church in 1935 and instituted a tradition of presenting a dramatic reading from Charles Dickens's *A Christmas Carol* at each of his twenty-two Christmas sermons in Cleveland prior to his retirement in 1956. Dr. Whyte also established a candlelight service in 1943. Originally held on the Friday before Christmas and then on the Sunday evening prior to Christmas, the now-traditional candlelight Christmas Eve ritual began in the early 1970s.

Catholic followers populated Cleveland later than Episcopal and Presbyterian worshipers. The first resident priest arrived in 1835; before that, missionaries had visited the city. In 1847, St. Mary on the Flats, a small and poor congregation, comprised Cleveland's only Catholic church. The following year, construction began on the Cathedral of Saint John the Evangelist located on East Ninth Street. Numerous fundraising events (including an excursion to France) allowed the cathedral to open in 1852, although more than thirty years would pass before interior and exterior decorations, including stained-glass windows, were added.

In 1894, Reverend Patrick Farrell employed rhetorical questions to caution the congregation against drunkenness and other excesses on Christmas Day: "Does the coming of the Savior mean that you are to follow your sensual passions, every shameful desire? Does it mean that you are to celebrate the coming of the infant Jesus by drunkenness, by impurity and by all that men call pleasure in this world of ours?"

Whatever the reaction to Reverend Farrell's sermon, he fared better than the pastor of the Hungarian Protestant Church on East Seventy-Ninth Street who delivered a fiery Christmas sermon four years later. The pastor scolded his flock for failing to contribute to a missionary fund that other Hungarian churches had generously supported. During the homily, a parishioner leaped to his feet, yelling, "Come down from the chancel! Away with you! Get out of here!" The service ended as the reverend descended from the pulpit. The parishioner, charged with disturbing a church service, incurred a five-dollar fine. Pastor Farrell returned the following week.

Catholic church rules in the nineteenth century forbid masses from starting after the noon hour. The cathedral scheduled Sunday worship services from 5:00 a.m. until noon, adding a 4:30 a.m. mass in 1901. A change in church rules allowed a midnight mass to begin in 1922. In 1929, several hundred newspaper workers attended a 2:00 a.m. Sunday "Printer's mass" after petitioning the church to schedule the service for the many downtown newspaper workers who ended work around that time. The service additionally attracted theatergoers attending late-evening performances and even the visiting performers, stagehands and orchestra members. In total, the cathedral celebrated eleven Sunday masses each week in 1929. The midnight mass and Printer's mass both continued until 1967.

In 1953, churches throughout the Cleveland Catholic diocese offered approximately two thousand Christmas masses. Radio stations broadcasted services from the downtown Cathedral and St. Paul's Church (located on Euclid Avenue at East Fortieth Street), but radio listening did not fulfill the Catholics' Sunday church obligation. In this period, St. Paul regularly offered eight Sunday masses, beginning at midnight and ending at noon. Christmas Eve masses at the Cathedral still attract capacity audiences.

During World War I, patriotism dominated a 1917 community Christmas service at the downtown Chamber of Commerce Auditorium. Speakers urged worshipers not to lose faith in Christianity and led prayers for America's armed forces. They predicted the fulfillment of prophecies of peace and viewed Christianity as the foundation of future world governments. In their opinion, strengthening soldiers' resolve and keeping religion and democracy

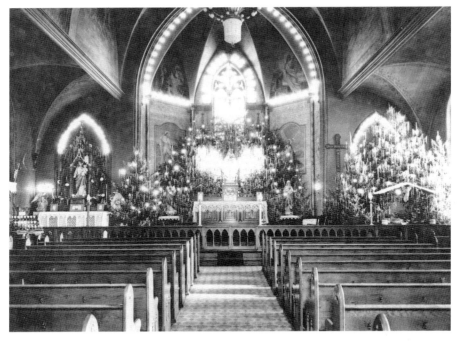

Originally an Episcopal church anchored by Euclid Avenue millionaires, St. Paul has been a Catholic shrine since 1931. This image shows the church decorated for Christmas in the 1930s. *Courtesy of Cleveland Public Library, Photograph Collection.*

alive depended on the observance of Christmas, the care of the poor and the preservation of the home.

Customs and traditions originating in other countries have been and still are vital parts of Christmas celebrations. Back in 1910, Germans decorated their trees on Christmas Eve while their children slept. The distribution of presents followed the holiday dinner. On Christmas Day, Italian men clothed in velvet coats and trousers and women outfitted in brightly colored dresses, shawls and silk scarves crowded the sidewalks and streets of Little Italy on their way to church. Christmas dinner followed, with turkey, chicken or other meats and side dishes of macaroni and spaghetti. Visits to relatives', friends' or neighbors' homes concluded the day of celebration.

Armenians rose at 4:00 a.m. to attend church services that lasted until nearly noon. In 1912, Armenians from Cleveland, Youngstown, Elyria, Akron and other communities gathered in a hall at Broadway Avenue and East Seventy-First Street to stage a Christmas celebration. Chinese grocery

Completed in 1912, St. Theodosius is Ohio's oldest Orthodox Christian church. *Courtesy of Cleveland Public Library, Photograph Collection.*

stores along Ontario Street displayed large bowls filled with oranges and nuts. Laundry owners presented their female customers with silk handkerchiefs and Christmas cards. Hungarians staged home gatherings and dinner parties. Because of calendar differences, Turks celebrated Christmas on January 6. On January 2, they began a Christmas fast by abstaining from consuming meat, fish and eggs.

Santa Claus, dressed in white, arrived on December 6 in Bohemian households; he carried a big stick and a bag filled with small cakes. Children who prayed for Santa received a cake but no toys. Children who refused to pray for Santa risked a beating with the stick. Slovenian families celebrated Christmas Eve with an evening meal served on a white tablecloth. Later, families attended midnight mass with the fathers leading the walk to church. On Christmas morning, carrying a bowl of holy water, the household's oldest woman blessed each room in the home. The father placed a lighted candle on the Christmas tree to conclude the ritual.

In the 1920s, Russians visited family and friends during the week before Christmas. At dinner, straw placed under the tablecloth and chairs signified the stable that accommodated Christ's birth. Members of St. Theodosius Russian Orthodox Church in Cleveland's Tremont neighborhood gathered

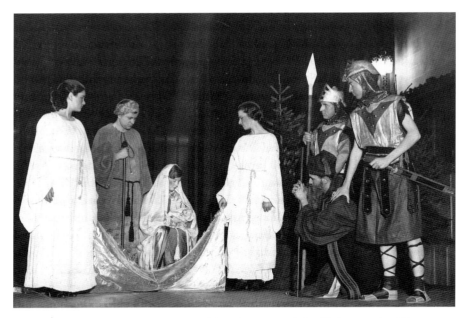

Above: The Epworth Euclid Methodist Church presented the Christmas play *The Innkeeper of Bethlehem* in the 1930s, 1940s and 1950s. *Courtesy of Cleveland Public Library, Photograph Collection.*

Opposite: In the 1950s, the Men's Club of St. Colman's Church (located at West Sixty-Fifth Street and Madison Avenue) constructed and displayed this outdoor crib. *Courtesy of Cleveland Public Library, Photograph Collection.*

after holiday dinners to sing folk songs of the Volga. Some families continued an old custom in which the eldest at the dinner table made the sign of the cross with honey on the diners' foreheads. Excited children anticipated opening the presents that had been placed under the Christmas tree by Grandfather Frost.

On Christmas Eve 1938, a male choir of 20 sang a Slovak Catholic mass at St. Benedict Church located on East Boulevard. The next day, a chorus of 150 schoolchildren presented a production of *The Shepherds in Bethlehem*, recited entirely in Slovak. Also in the 1930s (and revived several times in the 1940s and 1950s), the former Epworth Euclid Methodist Church (located on East 107th Street in the University Circle neighborhood) staged *The Innkeeper of Bethlehem*, a Christmas pageant narrated by Dr. Oscar Thomas Olson, the church pastor, and written by his wife. In 2010, as part of a merger with the First United Methodist Church of Cleveland, the church was renamed the University Circle United Church.

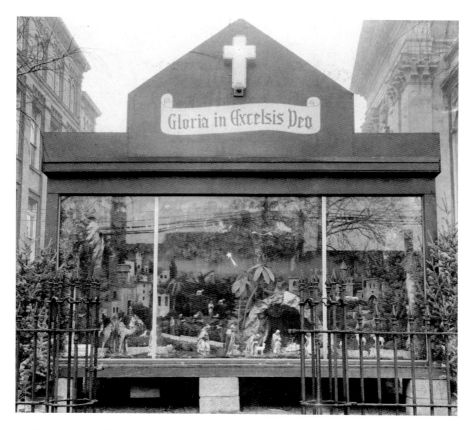

Between the first Sunday of Advent and Christmas Day in 1958, a statue of Christ was shared among the parishioners of Our Lady of Fatima. The diverse church, located on Lexington Avenue in the Hough neighborhood, included Puerto Rican, African American and white members. Prior to Christmas, families invited their neighbors to join them in prayers. On Christmas Eve, a women's choir sang Christmas carols in Spanish. Then, an eleven-year-old Polish American boy carried Christ's statue into the church in a solemn procession.

At both the midnight and Christmas Day masses in Holy Family Catholic Church (East 131st Street) in 1960, a choir of Czechoslovakian refugees sang traditional Christmas carols from Bohemia. At St. Sava Serbian Eastern Orthodox Church (1565 East Thirty-Sixth Street) parishioners celebrated their 1962 Christmas Eve by cutting a yule log into three pieces (symbolizing the Holy Trinity) and fasting with meatless dinners composed of vegetables, nuts and dried fruit. Following dinner, the father figures of the houses threw

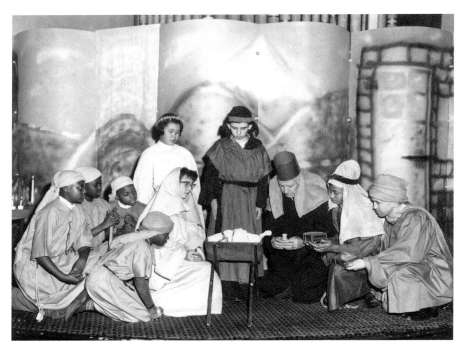

In 1960, the members of the Hough Avenue Evangelical and Reformed Church performed a dramatization of the nativity scene. *Courtesy of Cleveland Public Library, Photograph Collection.*

walnuts into the four corners of the dining room to represent the sign of the cross. Following church service on Christmas Day, the worshipers enjoyed a dinner composed of stuffed cabbage, suckling pig and chicken.

Today, Cleveland's ethnic diversity is reflected in the Christian services conducted in at least fourteen languages other than English: Arabic, Chinese, German, Hungarian, Igbo, Italian, Latin, Lithuanian, Polish, Romanian, Slovenian, Spanish, Ukrainian and Vietnamese.

Christmas songs have existed almost from the beginning of Christianity; the first known composition is the now obscure "Angels Hymn" and was written in 129 CE. The early songs, which were usually centered on the nativity of Christ, are now classified as hymns. According to a legend, in 1223, Francis of Assisi arranged a manger scene in Italy and burst into a song of praise and, in the process, created the first Christmas carol—a refrain much less formal and solemn than a hymn.

In the 1890s and continuing to the present day, church choirs routinely incorporate inspiring carols composed during the nineteenth century: "Silent

Left: In 1924, two Lincoln High School Campfire Girls used a coffee cup to characterize a mediaeval-looking lantern as they sang "O Little Town of Bethlehem" at a school assembly. *Courtesy of Cleveland Public Library, Photograph Collection.*

Below: This image portrays one of the seventy-five groups that the Cleveland Music Settlement dispatched in 1926 to sing Christmas Eve carols in homes, hospitals and orphanages. *Courtesy of Cleveland Public Library, Photograph Collection.*

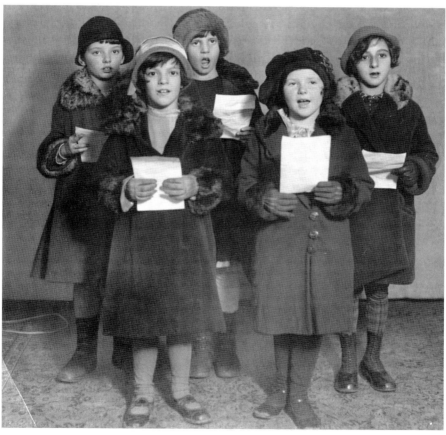

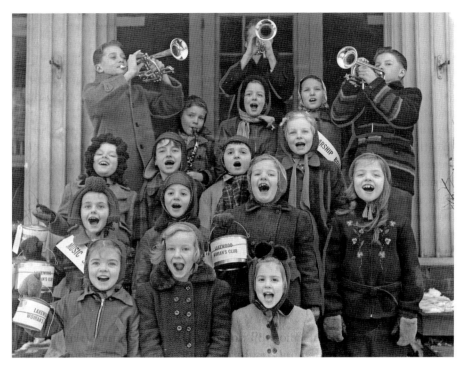

In 1961, children practiced singing Christmas carols for a program sponsored through a Lakewood Women's Club scholarship. *Courtesy of Cleveland Public Library, Photograph Collection.*

Night" (1818), "The First Noel" (1823), "O Holy Night" (1847) and "Away in the Manger" (1885). Secular songs written during the period, such as "Jingle Bells" (1857) and "Up on the Housetop" (1864) also created an ambiance that encouraged celebration, although "Jingle Bells" was originally written as a Thanksgiving tribute.

Religious holiday music is not confined to Christmas carols. In 1868, British operatic soprano Euphrosyne Parepa-Rose sang "I Know That My Redeemer Liveth" from Handel's *Messiah* during a Christmas Eve concert at Case Hall on Superior Avenue (the current site of the Metzenbaum courthouse). Since then, segments of *Messiah* (originally intended as an Easter composition) have been presented in numerous churches during the Christmas season.

7

Christmas Cards

THE RISE AND REGRESSION

\mathcal{O}n 1843, Sir Henry Cole helped establish a new "Public Record Office" in Great Britain, the forerunner to the modern post office. To inspire the public's use of this new organization, Cole originated the Christmas card tradition by encouraging people to mail cards to relatives and friends during the holiday season. Sir Henry and his artist colleague, John Horsley, even designed the first Christmas card. The layout comprised three hand-colored panels; the left scene portrayed caring for the poor and feeding the hungry, while the right side depicted clothing the naked. The center panel, which illustrated a family raising wine glasses for a toast during a Christmas dinner, provoked objections because it pictured a child holding a glass of wine.

Imported Christmas cards emerged in the United States in the late 1840s, but they created little interest, primarily due to their cost. Robert H. Pease, a lithographer in Albany, designed an advertising Christmas card in 1851, which also inspired only negligible attention. But cards soon increased in popularity as improved printing methods lowered their cost. In the 1860s, the most popular images conveyed the nativity scene, snow-covered landscapes and images not directly related to Christmas, such as flowers, seascapes and kittens.

In 1875, Louis Prang, a Boston printer who had previously created cards in Great Britain, began mass producing much-less-expensive Christmas cards by perfecting a multicolored lithographic printing machine. His first card consisted of a flower image (today, it would be more appropriate

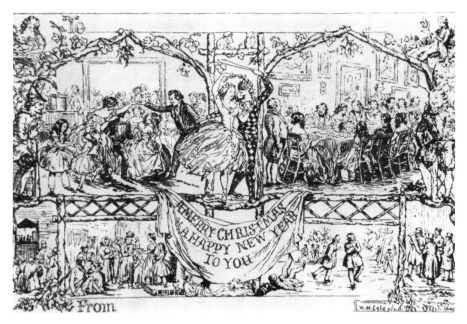

This preliminary sketch (1842) anticipated a design for a very early Christmas card printed in 1848. William Maw Egley's four illustrations depicted extremes in holiday activities: an elegant ballroom scene (*top left*), a fancy Victorian Christmas dinner (*top right*), underprivileged people in a soup line (*bottom left*) and walking during inclement weather (*bottom right*). *Courtesy of Cleveland Public Library, Photograph Collection.*

for Mother's Day) and the message: "Merry Christmas." Prang's early cards often consisted of flowers, plants and children with a "Best Wishes" message. Although they were intended primarily for Christmas, Prang also sold the cards during the Easter season. He expanded his offerings by reproducing famous American artists' paintings and offering cards depicting religious themes. Prang dominated the American Christmas card market until competition from inexpensive imported European cards developed in the 1890s.

In the 1880s, Cleveland merchants advertised a wide variety of cards priced from one cent to two dollars. Foil ribbons and silk fringes enhanced expensive engraved cards. Wealthy residents also chose satin cards that incorporated the phrase "A Merry Christmas," which was carved from silver- or gold-colored metal. Winter scenes and poinsettias ranked among the most popular images printed on the Christmas cards. The Levy & Stearn Company specialized in hand-painted cards on satin, celluloid, gauze or kid. For the less wealthy, Burrows advertised "a large selection at

reasonable prices" and the Bailey department store offered greeting cards for one and two cents.

Sharpshooter Annie Oakley is believed to have inaugurated the "personalized" Christmas card. In 1891, while in Scotland, she dispatched cards that incorporated her photograph to friends and family in the United States. In September 1913, the Halle company encouraged customers to order personalized Christmas cards in September. Customers selected their favorites styles and composed personal sentiments to be printed on the cards. Shoppers could also submit their own pictures to be included on the cards. The cost of custom-made cards varied greatly, depending on the complexity of the design. Customers finalized their orders eight weeks prior to Christmas Day, since the cards were printed in England.

During World War I, Cleveland stores advised that customers who were sending Christmas cards to servicemen overseas should mail their greetings prior to October 31. Stores charged between five and fifteen cents for military-themed messages, such as:

The English lass is fair o' face, Italian girls are pretty;
The Belgium miss is famed for grace,
And French mademoiselles are witty;
But a lone little maid in the U.S.A.,
Sends you her love this Christmas Day.

In the 1920s, the Lindner department store displayed various styled Christmas cards that were imported from Austria and Italy. As automobiles became more commonplace, holiday greetings with images of the latest models appeared with messages, such as:

Down the hill she gayly races,
Up the hill she stoutly climbs,
With a motor-load of wishes,
For the merriest of times.

Beginning in the 1930s, several greeting card companies commissioned well-known artists, such as Norman Rockwell and Grandma Moses, to design greeting cards. Rockwell devised scenes typical of his unique perspective of American culture, from the fun and perils of decorating a Christmas tree to excited children unwrapping presents and an exhausted Santa Claus resting after finishing his Christmas deliveries. Grandma

Moses painted images of villages, barns, churches, sleigh riders and ice skaters. Mickey Mouse appeared on Christmas Cards, assuming some of the functions that were previously the responsibility of Santa Claus. One card depicted Mickey busily stuffing stockings that had been neatly hung on a fireplace mantle with care. The caption stated: "All through the house, not a creature was stirring, except Mickey Mouse." A short-lived fad in the early 1930s showcased brightly colored animals on Christmas cards. A red-and-white elephant accompanied the message: "It's a circus to wish you a Merry Christmas." Depression-inspired cards revealed Santa Claus wearing patched-up pants.

By the 1930s, nearly a century had passed without strict rules of protocol burdening the exchange of Christmas cards. The sender determined who should receive cards, the message's content, the appropriateness of handwritten versus engraved text and the size and shape of cards. But in 1935, etiquette authority Emily Post provided more structured guidance. She claimed the phrase "Mr. and Mrs." must never appear after the holiday message, as in, "A Merry Christmas and a Happy New Year. Mr. and Mrs. William Jones." Post advised that this mistake, often committed by "otherwise well-bred people," must be corrected to read "Mr. and Mrs. William Jones wish you a Merry Christmas and a Happy New Year." Post also stipulated that males must be mentioned first (never "Mrs. and Mr. Jones"); placing the female first, according to Post, creates "too much of an Amazonian effect."

In the 1940s, the Higbee and May Company department stores charged one dollar for fifty cards with an imprinted name. The Burrows store on Euclid Avenue marketed cards printed in nine foreign languages and promoted holiday cards with fitting messages for mothers, husbands, sons, daughters and sweethearts. These cards ranged in price from five cents to one dollar.

Britain banned the exchange of Christmas cards in 1941, explaining that the country desperately needed paper for "munitions and other essential purposes." In America, emotions reached a fever pitch following the bombing of Pearl Harbor. Well-known society columnist Cholly Knickerbocker (which was actually a pseudonym for a set of New York writers) related a story of a socialite who had ordered one thousand Christmas cards only to discover a "made in Japan" designation on each box. She told her butler to toss the entire shipment into the furnace. Knickerbocker ended the article by adding, "That's the way we all feel about the treacherous little nasties with bodies of Lilliputians and minds of

Left: Christmas cards displaying the American flag soared in popularity during World War II. *Courtesy of the author.*

Right: This World War II–era Christmas card imparted the sentimental message: "There will always be a Christmas; our flag is here to stay. So, go ahead and celebrate the real American way." *Courtesy of the author.*

rattlesnakes." During the war, the Lindner Company suggested purchasing Christmas cards that expressed faith in the American way of living and trust and confidence in the continuance of the beloved Christmas holiday. Cards during the war years featured American flags and shields with messages, such as, "From every mountainside, let freedom ring." Images also depicted Santa wearing a helmet instead of his traditional red-and-white cap.

Less than ten years after Emily Post printed her Christmas card etiquette columns, Americans who were sending cards overseas learned a brand-new protocol. Although a simple "Merry Christmas" message created no problems, censors viewed a nondescript-sounding addition, such as "write as soon as you receive this," as a possible secret code and would prohibit the mailing of the card.

After the war, old-fashioned sentiment returned. Popular cards featured carolers, sleigh riders, churches and farmhouses, all incorporating pristine, glittering white snow. But sentimentality didn't remain in vogue for long. In 1949, the Fred Harvey store in Terminal Tower promoted "Hobby Christmas Cards." One such card depicted a bowling ball scattering ten pins and combined it with the message, "Merry Christmas. Hope it's right down your alley." Another depicted a golf ball approaching a tee that inspired the wording, "Merry Christmas fore you." In the 1950s,

Top: As air travel increased in popularity, a Christmas card manufacturer created the message: "May your Christmastime be pleasant, and when New Year's Day begins, may your hopes have happy landings and the best of luck soar in." *Courtesy of the author.*

Bottom: Religious themes, first incorporated in Christmas cards in the 1860s, still convey the Christian significance of the holiday. *Courtesy of the author.*

brightly colored cards concentrated on the prosperity of postwar America by portraying well-dressed husbands and wives in family settings.

By the mid-century, the exchange of Christmas cards had lost some of its formality. The image of a husband viewing approaching visitors featured the message, "The only thing that could possibly ruin this Christmas would be your family." Another card showed Santa dropping an atomic bomb down a chimney while exclaiming "Ho, ho, ho." Along with family members, the names of household pets appeared on some cards. In a few cases, Christmas cards in the 1950s lost more than just formality. In 1957, the U.S. House of Representatives asked the Post Office to investigate a growing number of complaints regarding obscene Christmas cards that were being widely offered for sale. In 1984, the government of the United Kingdom banned pornographic Christmas cards that were being imported from the United States.

Women undertook practically all of the exact hand coloring and dusting of the snow scenes that lent richness to the 1950s cards. They also bought 80 percent of the cards purchased in the United States. During the 1950s, Burrows asked $1.95 for twenty-five personalized Hallmark cards with the advertising byline: "Your friends will think they cost much more."

In the 1960s, the Higbee Company's marketing of Christmas cards had developed into a nearly eight-month

In 1955, the Republic Steel Company incorporated an image of its Cleveland plant on its Christmas cards. *Courtesy of Cleveland Public Library, Photograph Collection.*

ritual. Half-price clearance sales started immediately after the holiday, often extending into late February, and then resumed in July as preseason sales. Great fanfare accompanied the arrival of new cards in early September. The company attractively displayed more than one thousand designs on easels and in albums, where customers sat in comfortable chairs while browsing through the new collections. Some cards were imported from Italy, Scandinavia, England and Germany. The department store developed an exhibit titled "How a Greeting Card Is Made" that depicted the step-by-step process that was required to create a Christmas card from verse writing and sketching to printing, packaging and shipping to distributors.

Messages on cards in the rule-breaking 1960s featured text like, "You can skip all that jazz about the fat guy in the red suit—just send me a present." Stores marketed cards that were especially designed for babysitters, mail carriers, dentists, nurses, newspaper carriers, Sunday school teachers and neighbors. Anticipating his impending incarceration, Shondor Birns, one of Cleveland's most colorful gangsters, sent Christmas cards that featured a Santa Claus behind bars. In 1962, the United States Post

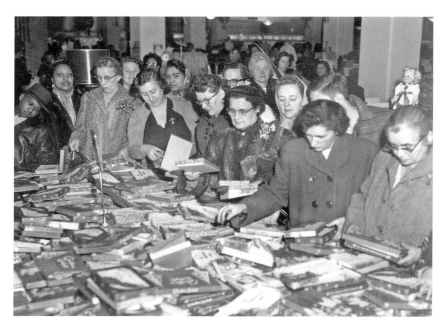

After-Christmas sales of cards and wrapping paper have remained a highly anticipated post-holiday ritual for more than a century. This image depicts a Halle department store sale in 1955. *Courtesy of the Cleveland Press Collection, Michael Schwartz Library, Cleveland State University.*

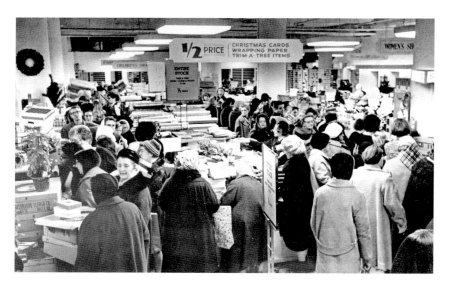

Shoppers at the May Company examine available bargains during an after-Christmas card and wrapping paper sale in 1967. *Courtesy of the Cleveland Press Collection, Michael Schwartz Library, Cleveland State University.*

Office introduced its first Christmas stamp. Americans purchased about one billion of the stamps, which displayed a wreath, two candles and the inscription: "Christmas 1962."

The irreverence of the 1960s continued into the next decades, with Christmas card messages such as, "I saw mommy kissing Santa Claus; the baby is due in mid-September." Another card depicted Santa and his reindeer perched precariously on the roof of a rural outhouse; a frustrated Santa yelled to the reindeer, "I told you to go the Schmidt house." Shifting gears into an extremely serious mood, the Higbee Company offered two thousand free cards to send to the hostages held in Iran in 1980.

Traditional Christmas card scenes have remained in style throughout more than a century of wars, cultural changes and fads. *Courtesy of the author.*

In 1948, United States citizens mailed an estimated 1.5 billion Christmas cards. Thirty years later, the number increased to 3 billion. But resistance to the rising postage costs, the creation of cards on home computers and the advent of email and social media drastically reduced the use of the post office as the primary source for sending Christmas greetings. In 2018, the estimated number of Christmas cards mailed in the United States dropped to 1.6 billion, slightly above the number from seventy years before.

The Onset of Cleveland's Great Department Stores

The humble debut of the Beckwith dry goods store in 1845 served as a harbinger for Cleveland's soon-to-evolve, magnificent downtown shopping district. Thomas Beckwith, who was born in Connecticut in 1821, arrived in Cleveland at the age of twenty. The short and stocky bearded man rose quickly from the position of store clerk to being the proprietor of his own establishment on Superior Avenue. During the store's first Christmas season, Beckwith advertised satin-striped brocades, cashmere, ginghams, prints, silks and shawls while promising "our stock is the largest and richest and best and cheapest."

After a short time, Beckwith changed his retailing focus by entering the floor covering and curtain business, stocking costly broadloom carpets, decorative window shades, fancy lace curtains and stunning tapestries. He advertised that the store's expansive carpeting inventory ranged from "cheap one-third cotton to magnificent velvet and Brussels cloth"—the latter attracting Cleveland's wealthiest families as customers. Beckwith promoted the beautiful carpets, curtains and mats as "easily adaptable for Christmas presents."

George P. Welch joined the Beckwith business in 1865; Frederick A. Sterling entered the company two years later. By 1868, the store's name had been changed to Beckwith, Sterling and Company. The business relocated to Euclid Avenue in 1874. Promoters chose the beautiful store as the site of an 1877 charity ball; a huge pile of carpets, utilized as a platform for the musicians, afforded the only hint of the building's status as a retail

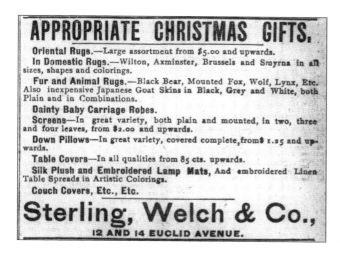

APPROPRIATE CHRISTMAS GIFTS.

Oriental Rugs.—Large assortment from $5.00 and upwards.

In Domestic Rugs.—Wilton, Axminster, Brussels and Smyrna in all sizes, shapes and colorings.

Fur and Animal Rugs.—Black Bear, Mounted Fox, Wolf, Lynx, Etc. Also inexpensive Japanese Goat Skins in Black, Grey and White, both Plain and in Combinations.

Dainty Baby Carriage Robes.

Screens—In great variety, both plain and mounted, in two, three and four leaves, from $2.00 and upwards.

Down Pillows—In great variety, covered complete, from $1.25 and upwards.

Table Covers—In all qualities from 85 cts. upwards.

Silk Plush and Embroidered Lamp Mats, And embroidered Linen Table Spreads in Artistic Colorings.

Couch Covers, Etc., Etc.

Sterling, Welch & Co.,
12 AND 14 EUCLID AVENUE.

In 1893, rugs and robes headed Sterling, Welch and Company's suggestions for "appropriate Christmas gifts." *Courtesy of Cleveland Public Library and the* Plain Dealer.

store. Following Beckwith's death in 1876, the business became Sterling & Company and, in 1889, Sterling, Welch and Company. Beckwith's Euclid Avenue mansion, built in 1866, remains intact and now houses the Cleveland Children's Museum.

Meanwhile, William B. Davis, a native of Quasqueton, Iowa, founded a men's furnishings business in 1880; it was initially crammed into a twelve-by-eighteen-foot room on the third floor of a building on Superior Avenue at West Sixth Street. The company originally manufactured custom shirts for men but soon expanded into ready-to-wear shirts as well. In 1896, Davis moved to Euclid Avenue, constructing Cleveland's first retail business with an all-glass frontage. An expanding cliental necessitated two more Euclid Avenue relocations; the second, in 1917, provided space for women's and children's clothing. The company's satisfied customer list included presidents James A. Garfield, William McKinley and Warren G. Harding and business tycoon John D. Rockefeller. In 1927, at the age of seventy-seven, Davis resigned as president but remained chairman of the board, making daily visits to the store until 1937. He died four years later at the age of ninety-one.

In 1908, Max J. Lindner, Morris Black and Max Hellman launched the Lindner Company, an East Ninth Street women's clothing store. Thirty-five-year-old Lindner, a New York City native, relocated to Cleveland. Hellman and Harvard-educated Black had already built impressive resumes as veteran Cleveland clothiers. The company stocked suits, gowns, coats, skirts, blouses, petticoats, hats and children's dresses. Advertising for its initial Christmas season, the store declared that "the most acceptable Christmas gifts are those

that have use as well as attractiveness," such as mid-winter fur coats with matching neckpieces ("good in style, rich in comfort"). Lindner's holiday blouse assortment featured everything from plain linen to Irish crochet and elaborately decorated Cluny lace shirts.

The business eventually grew into the largest women's specialty clothing store in Cleveland, but Lindner remained with the company for only twelve years. In 1920, he joined the May Company as a buyer, a position he held until his retirement in 1945. Hellman reigned as the company president until his death in 1923; Black assumed control until his retirement in 1936. In 1949, the stores that had originally been founded by Max Lindner and William Davis merged. Almost immediately, Sterling & Welch and Lindner & Davis joined to form the Sterling-Lindner-Davis Company, one of downtown Cleveland's "big six" department stores.

A monumental event in Cleveland's retailing history occurred on September 10, 1860: John G. Hower and Edwin Converse Higbee inaugurated the Hower & Higbee dry goods store on the north side of Superior Avenue one door east of West Third Street. Born in Pennsylvania to the wife of a Methodist Episcopal minister but raised in Burbank, Ohio, Hower operated a general store before relocating to Cleveland. Higbee, a native of Lodi, Ohio, had previously worked in his father's store. The new company started in a less than auspicious manner. A pair of windows,

Hower and Higbee launched their dry goods store seven months prior to the beginning of the Civil War. Their initial advertisements focused on dry goods, blankets and prints. *Courtesy of Cleveland Public Library and the* Plain Dealer.

one on each side of a ground-floor entrance to the two-story building, emerged as obvious choices to attract attention by displaying the company's merchandise. The partners ordered fancy and expensive French plate glass to create a favorable first impression for their prospective customers. Just prior to the store's scheduled opening, a carpenter broke both windows during a botched installation attempt. Rather than delay the store's debut, Hower & Higbee substituted readily available ordinary glass, although it was probably not installed by the same carpenter. The fledging store's initial

Christmas offerings included Irish linens and flannels, brocade silks, lace veils, linen handkerchiefs and embroidered collars. Ten years after its founding, the prospering company relocated to a substantially larger building directly across the street. Christmas gift suggestions that year included black silk hose ($1.00 to $1.25), silk umbrellas ($2.00, $3.00 and $5.00) and silver table lamps ($7.00).

In 1897, Hower died after suffering a broken neck in a fall from a runaway horse and buggy traveling on Lake Avenue. Five years later, Higbee removed Hower's name from the business, renaming it the Higbee Company. In 1904, the thriving store moved again to a Public Square location near the current Renaissance Cleveland Hotel site. Following Edwin Higbee's death from pneumonia in 1906, his son William presided as company president. In 1910, the Higbee Company moved to a 330,000-square-foot facility on Euclid Avenue near East Thirteenth Street, directly opposite the Halle Company, its fiercest competitor. On September 8, 1931, the Higbee store relocated back to Public Square to a 1-million-square-foot complex. The company eventually evolved into a fourteen-store chain, continuing as one of Clevelanders' favorite Christmas shopping destinations for more than a century.

In 1870, the forerunners of two large department stores (the May and William Taylor & Son Companies) made their first appearances. Edward R. Hull and Christopher Richards Mabley founded a store located on the west side of Ontario Street, between Euclid and Prospect Avenues. The store originally specialized in men's and children's fashions while emphasizing attractive prices. As an aggressive promoter, Hull purchased large newspaper advertisements, created elaborate window displays and turned seasonal fashion changes into spectacular events that consisted of fashion shows, live music, gifts and souvenirs for ladies, along with store decorations highlighted by flowers, flags and folds of bunting. Three years after its opening, the store expanded after it purchased the next-door building. Mabley, a primarily silent partner, owned multiple stores in Michigan, where residents referred to him as the "merchant prince." In 1875, he liquidated his Cleveland interests, and he died ten years later. His widow created a social scandal when, a mere nine months after her husband's death, she married a much younger clergyman who had broken off his engagement to the daughter of a wealthy insurance executive to wed the former Mrs. Mabley.

In 1884, Hull opened a branch location—a novel concept then—on West Twenty-Fifth Street. He continued to operate the stores until 1890, when he and two partners (William F. Dutton and John C. McWatters) cofounded the E.R. Hull & Dutton Company. The downtown location moved across the street in 1890, to the east side of Ontario Street. A

Men's Overcoat Department.

This image depicts Hull & Dutton's men's overcoat department, which was located in their new store on the east side of Ontario Street. *Courtesy of Cleveland Public Library and the* Plain Dealer.

veteran retailer, Dutton had previously worked with Mabley. McWatters managed various departments within Hull's former downtown store. Samuel E. Graves, Hull's general manager, chose to retire but launched his own competing Euclid Avenue clothing store the following year. In 1891, Hull & Dutton added two additional floors, transforming itself into the largest retail clothing store in Ohio, with 57,600 square feet of floor space. In addition, the company owned a one-story building on Euclid Avenue, north of their main selling location. This annex later became the May Company's Euclid Avenue frontage.

In a monthlong contest during December 1891, Hull & Dutton "comfortably housed" an ox in a prominent display window. A mahogany bedroom set awaited the female shopper who came closest to guessing the ox's actual weight on January 2. The male with the most accurate guess received a gold coin in the exact amount of the animal's value. The male and female with the second-best guesses each received a gold watch. When the contest concluded, the store donated the meat from the slaughtered ox to four children's charities. The next season, a live ostrich replaced the ox in essentially the same promotional contest. The female customer who was nearest to guessing the bird's exact weight won a grand piano worth $550. The woman with the next-closest guess received a $75 gold watch. A

Hull & Dutton's highly unusual Christmas promotions included a contest to guess the weight of a live ox that was roaming in one of the company's display windows. *Courtesy of Cleveland Public Library and the* Plain Dealer.

separate contest for children, based on the same rules, resulted in the boy and girl with the best guesses each winning a pony. Adult males did not participate in this promotion.

The store created numerous Christian promotions not limited to the Christmas holiday. During the 1897 Easter season, Hull & Dutton exhibited Louis Ransom's seven-foot-tall sacred painting *Follow Me*, which depicted Jesus Christ surrounded by Martin Luther, John Calvin, John Wesley, John Murray, William Penn, Joan of Arc and John Wycliffe. Ransom asked $50,000 for the painting. In the Easter season of 1898, Hull & Dutton presented a Passion Play described as an exhibition of animated photography accompanied by singing, music and narration. Customers who made purchases at the store received free tickets.

During the 1897 Christmas season, the store promoted its vast selection of dolls for sale with this intriguing byline: "Pile all the stocks in all the other stores in a heap and there wouldn't be as many as Hull & Dutton have collected. Prices range from three cents to $4.95. Then, there are thousands of wonderful toys and games that skillful hands and clever wits have devised to amuse and instruct. The prices range from one cent to $25.00."

Amid continuing fanfare and excitement, Hull & Dutton, on April 5, 1898, relocated to a new seven-story store on Ontario Street. Less than three

The New Woman
Up to Date.

The A. D. 1900
Woman.

The Bicycle Girl of Today.

In 1895, a Hull & Dutton advertisement previewed the company's visions of the clothing twentieth-century women would wear as they evolved from Victorian ladies to Gibson Girls. *Courtesy of Cleveland Public Library and the* Plain Dealer.

months later, startled shoppers stared in disbelief as the business locked its doors and declared itself insolvent. The court allowed the company to reopen for a few months to liquidate its stock. In 1899, the then Denver-based May Company purchased the remaining assets of the failed Hull & Dutton store. Only interested in the physical building, the new owners announced the liquidation of old the store's unsold merchandise: "Not a dollar's worth of Hull & Dutton stock will be taken into the new store."

Debuting during the holiday season, the May Company enticed customers by staging a combined inaugural and Christmas sale, offering bargains in each of the store's fifty-two departments. For the ladies, the store offered seal jackets ($50.00), Hudson Bay beaver collarettes ($25.00), mink gloves ($2.50), solid gold broaches ($3.00 to $10.00), hat pins ($0.03 to $5.00) and dress patterns (chosen from among one hundred available selections), combined with six yards of cloth ($1.50). For men, suits ($10.00, $12.00 or $15.00) and imitation alligator slippers ($0.75) constituted popular items. One of the most intriguing sales consisted of two million handkerchiefs (correctly promoted as five apiece for each of Cleveland's four hundred thousand residents) each costing between $0.005 and $2.00.

In 1885, David Crow and Charles W. Whitmarsh founded Crow & Whitmarsh, a Euclid Avenue dry goods store composed of four floors and a

basement. In 1912, the May Company purchased the assets of the bankrupt company. Two years later, May Company constructed the still-existing building on the former sites of their old store and the previously Hull & Dutton and Crow & Whitmarsh businesses.

In 1870, the same year Hull & Dutton debuted, William Taylor and Thomas Kilpatrick (both Scottish immigrants) established a one-room dry goods store on Public Square near Euclid Avenue. John Livingstone Taylor, William's son, joined the firm in 1885; Kilpatrick relocated to Chicago the following year. A strict Presbyterian, William Taylor forbid any employee— no matter what position he or she held with the company—to work on Sunday. He also stipulated that curtains on display windows must be drawn on Sundays. In 1887, William died of consumption, and his son John assumed control of the company. In 1890, John married Sophia (Sophie) Strong. Born in Mexico, Missouri, in 1861, Sophia had moved with her family to Cleveland when her father accepted an engineering job with the city. In 1892, her thirty-one-year-old husband died of pneumonia. With no background in retailing, Sophia assumed control of the business less than three years after her marriage. She headed the department store as either the president or chairman of the board for the next forty-four years until her death in 1936. In 1907, the store moved to a new five-story building at 630 Euclid Avenue near the Hippodrome Theater. Six years later, Taylor added four additional floors to allow an expansion of the flourishing business.

After purchasing an estate in Bratenahl, Sophia attempted to rent two vacant homes on the property. She had no success because her rental conditions included stipulations that no alcohol could be consumed on the property and no elaborate entertaining would be allowed on Sundays. Following her residential relocation, she turned her previous home on Euclid Avenue in Euclid, Ohio, into a recreation facility for Taylor employees. The grounds included tennis courts, baseball diamonds and a golf course. Although all employees were welcomed, Sophia forbid alcohol or tobacco consumption, dancing and playing cards on the property. Following Sophia's death, the May Company purchased a substantial interest in the department store.

In 1881, Louis A. Bailey and two partners founded the Bailey Company dry goods and millinery store on the corner of Ontario Street and Prospect Avenue, about a block south of Public Square. The 1887, purchase of the store next door greatly enlarged the company's selling area. The Bailey Company's 1893 Christmas gift selections for men encompassed holiday neckties ($0.19 to $1.00), silk-embroidered suspenders ($0.09 to $1.00), all-

wool suits ($2.69, $4.80, $6.98 and $10.00) and all-wool overcoats ($3.95, $6.98, $10.00, $15.00). Ladies' gift items featured braided jackets ($2.98, $3.95 and $5.00) and silk and wool dress skirts ($5.00). Children's gifts included colored picture books ($0.02, $0.05, and $0.15). At $0.09 per pound, customers purchased molasses, taffy and mixed nuts.

In 1895, the company remodeled its store, expanding into five floors to enlarge its carpet, curtain, drapery and men's furnishings departments, and it added a large grocery store in the basement. Within the retail sphere, many viewed Bailey's as the most progressive store in Cleveland. Although appearing to be illogical, the company seemed almost capable of living up to the founder's motto: "Always the best, always the cheapest." Louis Bailey died in 1898. Within one year, the remaining partners merged with the Cleveland Dry Goods Store to create one of Cleveland's largest department stores; it erected a new ten-story building in 1910. The company soon expanded by opening a branch store on Euclid Avenue near East 105th Street and another store in Lakewood.

Born in 1814 in Herkimer County in central New York State, T.S. Paddock earned $1.50 per month as a youth in a brickyard to help support his widowed mother. He arrived in Cleveland at the age of twenty-two and established Cleveland's first company dedicated to selling furs. When Paddock died in 1891, brothers Samuel Horatio Halle and Salmon Portland Chase Halle purchased the assets of the Paddock's company, which consisted of a twenty-five-by-two-hundred-foot combination factory and retail store located on Superior Avenue near Public Square that specialized in fur coats and railroad and society caps.

Samuel and Salmon had grown up in a downtown Cleveland family home located on Bolivar Road. Their father, who owned a successful wholesale dry goods store on West Ninth Street, provided them with an early exposure to the world of business. Their background proved to be invaluable, since the Paddock company's sales had declined substantially. The Halle Company's first-day sales amounted to a paltry $55.96, and they deteriorated to $9.39 on the third day. But the brothers quickly instituted a substantial turnaround in sales. The company invested heavily in newspaper advertising, inviting Clevelanders to "use good common sense and buy from the Halle brothers." The company also introduced convenient evening hours for retail shoppers. Samuel utilized his outgoing personality to handle the company's personnel and public relations functions, while the more analytical Salmon concentrated on the office management and buyer segments of the business.

In 1892, the Halle store relocated to the Nottingham Building on Euclid Avenue, near East Sixth Street (the current site of the Beacon apartments), where the brothers advertised their business as "the finest fur and hat establishment in the city." The new location helped improve sales due to its proximity to the recently constructed and very popular Arcade on Euclid Avenue. In 1896, the brothers added ready-to-wear clothing, and they added a full line of women's apparel in 1901. In 1910, the store moved to Euclid Avenue at East Twelfth Street. Four years later, the Halle Brothers nearly doubled the size of the store by constructing a major addition.

Emphasizing higher-end merchandise and personal service—the latter accomplished through a comprehensive employee training program—the department store developed into a trusted name among Cleveland shoppers. In 1927, *Time* magazine referred to the Halle Department Store as "one of the best run department stores in the country." Branch stores in Erie, Pennsylvania (1929), and Canton, Ohio (1930), represented Cleveland's first satellite stores outside of the Cleveland area.

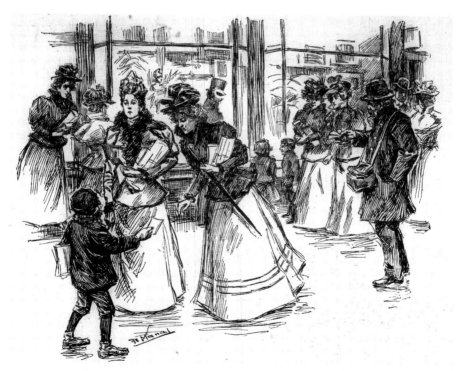

In 1898, wearing Victorian clothing remained the most fashionable alternative when shopping on Euclid Avenue. *Courtesy of Cleveland Public Library and the* Plain Dealer.

Samuel married one of the store's clerks in 1901 and remained an active member of the store's management until his death at the age of eighty-six in 1954. The day before he died, Samuel toured the store to observe its operations. Twenty-one years earlier, at the age of sixty-five, he learned to fly an airplane and earned a private pilot license. In 1921, Salmon retired from active participation in the business to devote his time to philanthropic activities.

Many other downtown Cleveland retail establishments possessed the opportunity to grow into major department stores. The "big six" absorbed some of these businesses, while others did not survive the heightened competition created by the large department stores. Others endured but then failed during the Great Depression.

During the first decade of the twentieth century, the largest downtown department stores used advertising messages to promote their core values and sales philosophies. The Halle Company touted "a remarkable exhibit of stylish clothing at prices no more than covering manufacturing costs." Hower & Higbee promised "merchandise appealing to refined tastes, good judgement and economical purchases." Lindner believed the most acceptable products "are those that have use as well as attractiveness." The Taylor department store once quoted a comment from a loyal customer who stressed the store's dependability: "I never look for sensational bargain sales but feel that I'm getting good value in every purchase." The May Company claimed, "If there is anything that can be imagined not found at the May Company, it would certainly prove a marvelous curiosity."

Downtown Christmas Shopping

THE RISE TO PROMINENCE (1845–1929)

On 1845, Cleveland's ten thousand or so inhabitants traveled to Superior Avenue between West Third and West Ninth Streets around December 23 to begin their Christmas shopping. Watson's Great Variety Store emerged as the go-to place for Christmas gifts like china sets, perfumes, shells, fruit and toys. Nearby, W.H. Smith focused on books, engravings and fine stationery. The S. Brainard Company specialized in musical instruments, engravings, perfume boxes and evening dress fans.

In the late 1840s, a severe economic depression motivated merchants to underscore the inexpensiveness of their Christmas merchandise, a practice that extended well into the next decade. S. Hyman's dry goods store sold tablecloths and covers, along with napkins, at "very cheap prices." The Dietz and Brothers Company promoted gold and silver watches, fine jewelry, fancy goods and toys, each item advertised as "a cheap present." J.R. Albertson offered Christmas gift selections in large quantities, varieties and styles while expounding upon his selling philosophy: "Success attends the man that sells cheap."

On January 8, 1850, Cowles & Albertson helped establish the after-Christmas clearance sale tradition by advertising that "Christmas presents must be sold." The store's discounted merchandise included eight bushels of watches and jewelry, three to four hundred pounds of silverware, an endless variety of fancy boxes, baskets and cases along with five hundred thousand curiosities.

OLD SANTA CLAUS

HAS as usual deposited his WARES where he well knew they would be freely dealt out amongst the rising Generation:

Christmas and New Year's

Toys and Presents.

WATSON'S

IS THE PLACE TO GET THEM,

As he is determined to sell off his big stock of them during the Holidays, even if he does not get first cost.

—ALSO—

CANDIES, TOYS AND CONFECTIONARIES.

P. S.—As they are NOW READY, we hope ladies and gentlemen will call while there is a chance to select.

dec20 **J. W. WATSON,**

The J.W. Watson store offered a wide variety of Christmas gifts in this 1847 advertisement. Although the store claimed to carry "all the necessities, as well as some of the luxuries of life," it failed to survive past 1849. *Courtesy of Cleveland Public Library and the* Plain Dealer.

During the Civil War, women treasured bonnets, silk scarfs, wool shawls, hoopskirts and corsets as Christmas gifts. Moustache cups, wigs, stereoscopic views and vulcanite-based false teeth reigned as preferred gifts for men. Solomon's Optical suggested that "Solomon's Celebrated Spectacles," mounted in gold, silver or steel, were appropriate Christmas gifts. For those who were not in need of spectacles, the company proposed field glasses, opera glasses, microscopes or microscopic telescopes as suitable alternatives. After the war, music boxes, glove boxes, jewel cases, silver tea sets, jewelry and watches headed the list of popular presents for ladies. Very practical women preferred furs, gloves, mittens and sleigh robes to help cope during the cold carriage-riding season.

In 1867, Superior Avenue still reigned as Cleveland's major commercial street; although, near Public Square, a few businesses had encroached on the fine homes on Euclid Avenue. Volan's Euclid Avenue general purpose store advertised Christmas items ranging from tree trimmings (lanterns, globes, wax candles and glass balls) to specially designed holiday cakes.

By the 1870s, after-Christmas clearances had become solidly entrenched rituals among holiday shoppers. Immediately after the 1868 Christmas selling season, the A.M. Kline Company offered toys and fancy goods at half price. Seven years later, the *Plain Dealer* reported, "Toy dealers and other traders in Christmas goods are ready to sell their surplus stock at a liberal discount."

In 1872, Fuller, Atwood & Estabrook on Superior Avenue suggested, "Nothing is more appropriate or delights the ladies more than furs." The company advised its customers that, although the store carried a wide selection of expensive seal coats, cheaper mink furs could be purchased instead. Meanwhile, E. Stair &

Company, a Superior Avenue competitor, aggressively promoted sets of a mink muffs and caps, along with gloves, that ranged in price from $15 to $150.

The growth of department stores and smaller shops created demands for additional space that Superior Avenue's shopping district could not accommodate. To sustain their expansions, retailers set their sights on Ontario Street and Euclid Avenue near Public Square.

By 1875, Cleveland's population had soared to well over 100,000. The era of waiting until December 23 to begin Christmas shopping had long passed into forgotten history. In mid-December, eager Christmas shoppers crowded streets and stores, while retailers remained open into the evenings. Although the expression "window shopping" would not be coined until 1904, in 1875, the *Plain Dealer* suggested, "Those who have no money can at least enjoy the pleasure of flattening their noses against [store] windows and looking at the handsome things exposed to view."

In 1876, Alexander Graham Bell introduced his latest phenomenon: the telephone. A year later, the Forest City Varnish and Oil Company, located on a corner of East Fourth Street and Euclid Avenue, installed Cleveland's first telephone. The company strung wires for three-quarters of a mile to a satellite facility. Although they emitted nearly perfect reception, the cost of telephones initially confined their appeal to either businesses or wealthy citizens. In 1902, the Cleveland Telephone Company (a forerunner to Ohio Bell) determinedly pursued the residential market with advertising, implying the monetary value of residential telephones: "A telephone at home earns money and saves money—something which cannot be credited to any other convenience of the household, and yet, how few know of it." The company even promoted telephones as holiday presents: "Can you imagine a more acceptable Christmas gift than a telephone?" Partly because of the high cost of ongoing usage, the telephone did not become a common gift until the 1950s, with the introduction of designer colors and multiple phones located in kitchens and bedrooms. The "Princess telephone," introduced in 1959 and weighing only forty-two ounces, quickly became a staple for teenage bedrooms. To this day, some telephone users continue to use the Princess phone.

TELEPHONE

Can you imagine a more acceptable Christmas gift than a Cuyahoga telephone?

Just call Central 31 and we will send a courteous and intelligent solicitor.

Are you in the book?
Have you wires enough?

Cuyahoga Telephone Company
Electric Building Prospect street

In 1902, the Cuyahoga Telephone Company promoted its product as "an acceptable Christmas gift." *Courtesy of Cleveland Public Library and the* Plain Dealer.

A thirty-eight-month economic recession from 1882 to 1885 discouraged extravagant Christmas shopping. In 1884, the year of a severe financial panic, an advertisement by A.S. Herenden Furniture on West Sixth Street addressed the downturn head on:

> *We all know that the times are hard, that money is scarce, and that everybody wants to save money this season. In fact, everyone has to do it whether he wants to or not. Retrenchment is the order of the day. There are but two ways to economize; one is to buy fewer things, the other is to pay lower prices for what you do buy. We have adopted the lower price side of the equation.*

The company went on to explain, "Holiday prices are so low that in many instances one dollar will now buy goods that readily sold for two dollars when times were good." Herenden gathered a collection of their best deals into one room that the company referred to as "the hospital, a veritable slaughterhouse of prices." Reductions at the faux hospital included a large, solid walnut bookcase ($110 reduced to $63) and a three-piece solid mahogany, horse-hide leather library (set of bookcases, $200 reduced to $95).

In 1881, a year prior to the beginning of the downturn, expected December shopping crowds prompted the E.L. Baldwin Company to begin selling an immense stock of holiday goods on the Friday after Thanksgiving. By 1889, the custom had become fairly standard because, as the *Plain Dealer* explained, "The feminine mind leaps out and spans the little space between the turkey of Thanksgiving and the plum pudding of Christmas." The practice, continued by retail stores for decades, recently reinvented itself as "Black Friday," a day of fantastic bargains and discounts. Department stores in the 1880s also expanded their shopping hours. In 1888, the E.R. Hull & Company remained open, beginning on Monday, December 17, until 10:00 p.m. each evening and, on Saturday, December 22, until 11:00 p.m. Christmas present selections included $0.50 silk handkerchiefs, silk and cashmere mufflers ($0.25 to $7.50), satin suspenders ($0.98), silk suspenders ($1.00 to $2.50) and inexpensive men's underwear, the latter referred to as "a sensible Christmas present."

Company records indicated Isaac Levy and Abraham Stearn founded their specialty products and toy store in 1862. Yet an employee discovered an eight-page flyer with an 1859 date referring to the same store name at the identical address, Superior Avenue at West Ninth Street. Whenever its

actual inception, Levy & Stearn developed into Cleveland's leading retailer for children's toys. Girls dreamed Santa would deliver the beautiful doll they discovered in a Levy & Stearn store window and fantasized Santa might even include a dollhouse and furniture. Although the choices of dolls varied through the years, the selection remained enormous. In 1899, French dolls in several sizes ($1.50 to $15.00) moved their eyes and turned their heads. Double-faced dolls laughed on one side and cried on the other. In 1908, imported thirteen- to eighteen-inch German dolls sold for $1.75 to $3.00, while twenty- to twenty-four-inch dolls with opening and closing eyes commanded $4.25 to $6.50.

Boys and girls both relished Christmas gifts of games, tricycles, bicycles, velocipedes, sleds, wagons and rocking horses. As the century ended, Levy & Stearn promoted mechanical toys capable of "moving, walking, performing and dancing in the most grotesque and life-like manner." The store also maintained a large selection of the latest craze, steam toys (locomotives, fire engines and yachts), in which real steam turned miniature gears to create movement.

In 1885, the Levy & Stearn Company relocated to Euclid Avenue. Levy retired in 1895; the renamed Stearn Company eventually transformed itself into a women's clothing shop. In 1946, the Lane Bryant chain purchased the company and, in 1950, removed the Stearn name from their store.

Although professionals had routinely utilized cameras since the 1870s, the required technical expertise and costly equipment strongly limited amateurs' use of photography. In 1888, when the Eastman Company replaced the photographer's glass plates with film, nonexperts joined the photography revolution. Eastman advertising promised, "You press the button; we do

Founded in 1889, Fowler & Slater remained in business until the Eastman Kodak Company purchased the company in 1930. In 1895, the shop sold a basic Kodak camera for five dollars. *Courtesy of Cleveland Public Library and the* Plain Dealer.

the rest." In 1889, the "Kodak Man," a representative of the Eastman Company, arrived at the downtown Cleveland Weddell House (a famous hotel at the time) to demonstrate cameras and exhibit photographs he had taken in San Francisco, including images of the interiors of opium dens. A newspaper reporter described the camera as "an innocent-looking little instrument packed conveniently in a leather case, which is slung over the camera artist's shoulder by a strap. The manipulator takes it in his left hand and presses a button with his right hand, whereupon a quick flash of light follows and negative is deposited on the film." The cameras soon became readily available. The downtown Burrows Brothers store marketed both Kodak and professional cameras, along with albums, carrying cases, darkroom lamps, tripods, developing and printing outfits and flash lamps as wonderful Christmas presents.

Through the decades, imaginative department store display windows have ranked among Christmas shoppers' fondest memories. Hull & Dutton assisted in establishing the tradition in 1890 by creating windows equipped with revolving platforms to exhibit clothing, household goods, hats and, in December, a variety of Christmas presents.

Electricity enhanced the development of exciting new Christmas presents geared toward entertainment. In 1899, Euclid Avenue's Cleveland Graphophone Company helped familiarize Clevelanders with talking machines and "indestructible" records. Similar to fans employed to cast enticing smells of nuts from shops onto sidewalks, the Graphophone Company transported sounds of popular music and politicians engrossed in stump speeches into the hearing distance of Euclid Avenue shoppers. The company's comprehensive assortment of recordings featured offerings in thirteen different languages: Bohemian, Chinese, Danish, English, French, German, Hebrew, Hungarian, Italian, Japanese, Polish, Spanish and Swedish. In 1904, William H. Buescher introduced Cleveland to Victrolas and Victor records by displaying both at the Hotel Gillsy and selling them at his nearby East Ninth Street store. Recognizing the potential as Christmas gifts, the May Company quickly opened a new fifth-floor Victor Talking Machine department to market the new invention for between fifteen dollars and one hundred dollars, with terms including free home delivery, no down payment and dollar-a-week installment payments. The May Company also offered a wide variety of popular records on sale for one dollar each or ten dollars for a dozen records.

Not all of the new electric innovations proved to be commercially successful. In 1914, the Erner Electric Company (with locations on both Superior and Euclid Avenues) advertised an item that failed to capture

The Bailey department store considered a Victrola "the ideal gift" for the 1910 Christmas season. *Courtesy of Cleveland Public Library and the* Plain Dealer.

shoppers' imaginations: an electric frying pan that could be used upside down as a stove ($7.00). But another innovation emerged as a staple Christmas gift for decades; the Salzer Electric Company (on Prospect Avenue) touted Lionel Train sets starting at six dollars.

Electricity had little to do with the popularity of another new entertainment product. The J.T. Wamelink & Sons Piano Company (on Superior Avenue) described the player piano in these glowing terms:

In 1906, the J.T. Wamelink Piano Company on Superior Avenue sold player pianos for $550 and up. A prominent musician and composer, Wamelink established his piano business in 1861. Although he died in 1900, the company continued until 1918. *Courtesy of Cleveland Public Library and the* Plain Dealer.

> *To the person who does not know a note of music, the player piano is available. He or she will open a little door in the front of the case, slip in a perforated music role, put their feet on the pedals that drop down for the purpose and then, while governing the expression absolutely by means of three little push buttons, will play in a way that few trained pianists can equal.*

In 1906, the pianos sold for between $500 and $900. Two years later, the May Company advertised player pianos, which were "so easy to operate

that even a child can play them," for $375 to $1,000. The W.W. Wirth Piano Company, located on Euclid Avenue near East Twenty-First Street, promised savings of $75 to $100 by purchasing a player piano "away from the high-rent district."

Christmas display windows greatly increased in sophistication in the early twentieth century. In 1914, crowds blocked the Ontario Street sidewalk in front of a Bailey Company window to view the most spectacular display to date. In the display, after sailing above a quiet country village in an airplane, Santa landed on the rooftop of a home, descended down the chimney, and placed a doll in each stocking hanging above the fireplace. Santa then exited, again through the chimney, and boarded his plane for the next stop.

In 1917, the May Company's basement gift wrapping and customer service departments supplied interpreters proficient in eleven languages (Bohemian, Dutch, English, German, Hebrew, Hungarian, Italian, Polish, Romanian, Russian and Slavic). Military and naval center booths on the

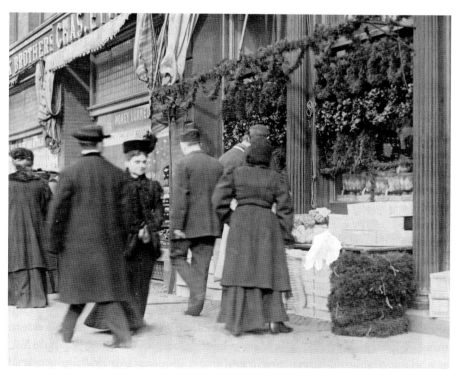

Curious window shoppers and hurried pedestrians travel down busy Euclid Avenue during the 1910 Christmas season. *Courtesy of Cleveland Public Library, Photograph Collection.*

main floor stocked gifts and comfort items for "the boys in training camps prior to their inevitable entrance into the Great War." The second-floor gift shop presented a collection of the "smartest, most-novel and quaintest items selected from throughout the store." The third-floor Christmas Bazaar comprised booth after booth of gifts in Cleveland's "most entertaining Christmas center." The third-floor Toyland marketed dolls from eighteen cents to twenty-five dollars, dollhouses from one dollar to twenty-five dollars and air rifles from fifty cents to three dollars.

Germany manufactured about 90 percent of the toys marketed in the Unites States before World War I curtailed European imports. In 1916, downtown department store newspaper advertising presented a mixed message to Clevelanders. The Halle Company warned toys would become scarce because of the European turmoil, but the May Company promised the availability of "thousands of imported toys from Europe in spite of the war." A year later, the ubiquitous phrase "Made in America" appeared on a large variety of toys as American manufacturers dramatically increased production. When the war concluded, a 70-percent duty on imported toys severely limited shipments from other countries. The Great Depression and continuing political unrest in Europe further restricted the availability of imported toys. By 1935, American manufacturers produced 90 percent of America's toys. In Ohio alone, 217 companies crafted toys.

Following World War I, amateur radio operators using makeshift receivers explored broadcasting on experimental stations. In 1921, the Salzer Electric Company on Prospect Avenue promoted wireless radio sets from $65 to $500. On March 2, 1922, WHK began broadcasting as Cleveland's first commercial radio station. With the arrival of the Christmas season, the May Company introduced a second-floor radio equipment department, which stocked a wide selection of equipment that

Radiola Super-Heterodyne

Technically the same as the Radiola VIII— only semi-portable—and has a separate loud speaker. Complete with Loud **$269** Speaker.

In 1924, the May Company promised improved radio reception with the use of superheterodyne technology. *Courtesy of Cleveland Public Library and the* Plain Dealer.

sold for as much as $250. An enlarged third-floor department debuted in time for Christmas shopping in 1923. For those who enjoyed tinkering with radios, the May Company marketed a crystal receiver equipped with headphones, an antenna, ground wires, clamps and insulators for $7.45. At the other extreme, already assembled radios placed in rich-looking cabinets commanded as much as $300.

Capitalizing on the popularity of two electronic wonders, the Wurlitzer Company (on Euclid Avenue) charged $189.50 for a combined radio and phonograph in an attractive cabinet in 1924. Meanwhile, the Halle Company offered Brunswick combined phonographs and radios for between $285 to $650. By mid-December, the stock of radios in many retail stores had been depleted. Manufacturers could not promise new deliveries until the next February at the earliest.

In the mid-1920s, operatic singer Enrico Caruso's records commanded $2.00 while Paul Whiteman's dance band music could be purchased for $0.75. Meanwhile, the May Company offered "the Christmas gift that brings a lifetime of satisfaction." The department store charged $175.00 for a new Zerozone electric refrigerator equipped with two trays for ice

By 1923, clothing for sale at the May Company reflected the dramatic shift from Victorian styles to jazz-age fashions. On the left is a bouffant frock in orchid chiffon with bands of orchid satin and gold lace ($55.00). To the right is a silver chemise ($89.50). *Courtesy of Cleveland Public Library and the Plain Dealer.*

cubes and seven and a half feet of shelf space—an old ice box could even be converted into the newer technology. After Christmas, the Rowe Fur Company suggested, "Buy furs with Santa Claus money." Located in the downtown Bulkley Building, the company promised "the best quality, the last word in style and at very special prices."

One of the most elaborate 1925 Christmas store windows didn't appear in a department store. Located in the window of a Studebaker automobile showroom (at 2000 Euclid Avenue), Santa readied himself to deliver Studebakers as Christmas presents in a stunning snow scene.

As the decade of prosperity ended, the *Plain Dealer* employed football analogies to describe the crowds shopping on Christmas Eve in 1929. At congested department stores, customers "ran 1890-model football plays up and down the aisles, pushing one another around something scandalous." The newspaper depicted shoppers' behavior as "good old-fashioned, bone-crushing drives over the center of the line, with everyone playing in the backfield and the fire wardens and store detectives running interference." Although the stock market had already crashed, the ensuing economic disaster had not yet cast its gloomy shadow over Cleveland's Christmas shopping.

Downtown Christmas Shopping

More than a year after the stock market collapse, Clevelanders in 1930 still jammed Euclid Avenue seeking Christmas bargains. Two years later, on Saturday, December 17, 1932, in just that one day, downtown stores sold $2 million in merchandise (more than $37 million in today's dollars). Yet both Christmas and non-holiday sales continued to plunge in the early 1930s. Responding to the ongoing dismal economic environment, the May Company advertised "Christmas cheer costs less this year." But retailers needed much more than frivolous slogans to attract Depression-era families into their stores. During the downward spiral, the May, Higbee and Halle department stores sponsored numerous free attractions to provide children with a day of happiness while possibly generating a few sales in the process. At the May Company, kids enjoyed simulated zeppelin rides, "Amusement Land" (a miniature version of an amusement park), Bo-Bo the Clown (who combined typical clown antics with magic tricks) and performing dog, cat, horse, bear, monkey and mule shows.

Throughout the 1930s, the store teamed with Walt Disney to present free revues headlined by Mickey Mouse, Pluto and the Three Little Pigs. Disney also staged Donald Duck's *Topsy-Turvy Circus* and, in 1937, offered free showings of *Snow White and the Seven Dwarfs*, a movie that had debuted in theaters earlier in the year. The decade closed with free performances of *The Lone Ranger and His Cavalcade of the West*. Kids watched in awe as General Custer presented an American flag to the Lone Ranger, Annie Oakley

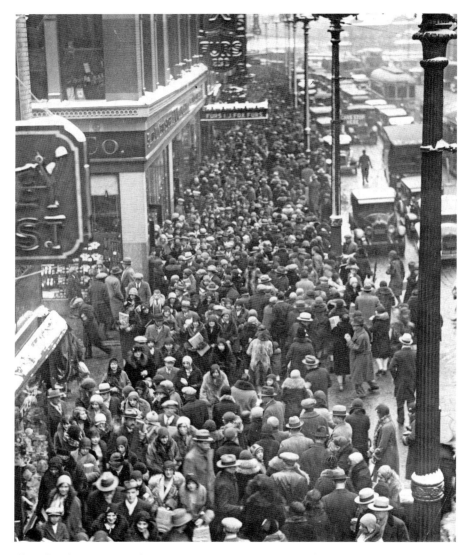

Above: Despite the economic slump, shoppers during the 1930 Christmas season lined Euclid Avenue at East Fourth Street. *Courtesy of Cleveland Public Library, Photograph Collection.*

Opposite: Bargain basement shoppers examined merchandise at the 1931 Higbee Company after-Christmas sale. *Courtesy of the Cleveland Press Collection, Michael Schwartz Library, Cleveland State University.*

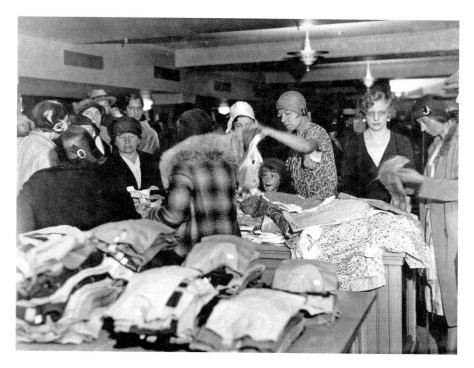

protected plainsmen from stampeding buffalo and Daniel Boone alerted settlers to an ensuing Indian attack. The fun concluded with a trip through the Lone Ranger's silver mine. The department store marketed a tie-in Lone Ranger board game, which sold for $1.00. Other Depression-era Christmas gifts included toy fire trucks with hoses that squirted a stream of water ($4.50) and alcohol-filled bottles chock-full of worms and seaweed ($0.15 to $0.20 per bottle) to be examined under a microscope ($1.00).

A train ride in the Higbee Company's sixth-floor Toyland transported children to "Storybook Land," where they marveled at an enchanted castle that was teeming with chills and thrills. Meanwhile, throughout Toyland, kids adored a wandering clown band, a magician, a cartoonist, a harmonica player, an organ grinder and his monkey, a farmer and his mule and frequent appearances by Humpty-Dumpty. Comic strip and radio star Buck Rogers, along with his friends Wilma Dearing and Dr. Huer, visited Toyland. Children rode on a spaceship or, for the less adventurous, a merry-go-round.

As the decade continued, children encountered live reindeer, the House of Mickey Mouse, performing ponies, a bucking mule, Tony and his monkey and Micky Mouse's Circus Train, which featured Mickey shoveling coal into the engine's fire box to keep the three red-and-gold cars

A postcard illustrated the interior of the Higbee Company's new Public Square location decorated for Christmas. *Courtesy of the author.*

traveling around a track. In a marionette show, Superman rescued a snow-bound Santa from his North Pole home. Adjacent to the performance, the store displayed a wood-pulp Superman doll with movable arms and legs, which was sold for $1.00. The Halle department store introduced a "modern Santa," who not only talked with children in person but also listened to messages the kids recorded while speaking into a microphone. Other entertainment included a trip through an enchanted forest, where, depending on the year, children delighted in meeting Mrs. Santa Claus, a fairy princess, Little Red Riding Hood and Little Bo-Peep. In a sheriff's office, Dead-Eye Dick, Two-Gun Tom and Billy the Kid stood ready to shoot from the hip. Cinderella, Pinocchio, Hansel and Gretel and Ali Baba and the Forty Thieves all starred in puppet shows.

No matter where the store presented its entertainment, children never strayed far from a special treasure depository that was filled with gifts, including a remote-controlled dump truck ($12.50), an electric train set ($31.50), a motor bike ($25.50) and a teddy bear ($6.00); $0.50 cents could purchase a Shirley Temple paper doll with two pages of dresses, while realistic Charlie McCarthy dolls sold for a pricy $7.95. As the 1930s ended, a Sonja Henie doll ($7.95) outsold the less-expensive Scarlet O'Hara dolls ($2.95 to $6.94). A streamlined white enamel toy kitchen ($1.95), which

In 1934, the Higbee department store offered free entertainment for children in the hope of attracting Christmas shoppers. *Courtesy of the Cleveland Press Collection, Michael Schwartz Library, Cleveland State University.*

included aluminum utensils, ranked high among popular Christmas, toys as did tin soldiers that came with a cannon and mechanical tank that shot sparks from a machine gun ($4.00).

In 1938, the Halle company created *The Animal Amateur Hour*, a program that was broadcasted from the second-floor toy shop over a special Santa Claus network; it presented exclusive interviews with a dozen inhabitants of the store's Stuffed Animal Kingdom. Not surprisingly, the store prominently displayed the animals for sale. The promotion included interviews and the opportunity to purchase Carlos Camel ($5.00), the Cowardly Lion ($2.50), Florence the cow ($2.00), Danny Donkey ($3.00), Honeybunch the koala bear ($2.50), Boobsie Bear ($1.50), Lancelot Leopard ($5.00), Hoppo the snow-white monkey ($2.00), Teddy and Scottie baby bears ($1.00), Mel-Mel (a baby panda) ($1.25), Lambie-Pie the lamb ($3.50) and Woolie Bear (he was so big children could ride on his back, $9.95).

Although department stores enticed children with special and often spectacular shows, bargain prices helped attract adult shoppers. In 1931, the Higbee Company emphasized Christmas price reductions. For the ladies, leopard coats dropped from $375.00 to $295.00, while muskrat garments declined from $95.00 to $72.50. An eighteen-inch-long string of culture pearls ("almost as perfect as the real thing") fell from $28.00 to $16.75. Permanent waves in the store's beauty salon declined from $12.50 to $9.50. Men's chinchilla overcoats, which were then sold for $37.00, had carried a $50.00 price tag the previous Christmas. All-wool boy's knicker suits dropped from $10.75 to $7.75.

In 1935, consumers who were not intimidated by the economic conditions scrutinized luxurious gifts at three Euclid Avenue jewelers. Cowell & Hubbard advertised a single-stone diamond for $2,400. Webb C. Ball priced a large marquise diamond flanked by two half-moon stones at $1,850. The Beattie company sold merchandise in a wide range of prices from a "simple but perfect" diamond ($25) to "fascinating gems" appraised at $25,000; a diamond and emerald watch sold for $1,100.

During World War II, the Taylor department store advertised "for the soldier, sailor or marine, the gift he wants most is your photograph." The store suggested purchasing six photographs "of the better kind" for seven dollars. The second-floor Canteen Shop stocked books, silver dog-tag chains, windproof cigarette lighters, duffel bags, wallets, shaving brushes and "scores of brilliant ideas for every man in every branch of the service." On the home front, easy-to-find female advisors, all wearing boutonnieres, assisted men in selecting Christmas presents.

Beginning early in November, Higbee holiday advertisements emphasized female fitness and appearance. Twelve "get in shape for Christmas" sessions in the sixth-floor salon, costing a total of twenty-five dollars, might result in a loss of eighteen pounds and reductions of five inches to the abdomen, four inches to the thighs and six inches to the hips. Nearer to Christmas, the Higbee Company promoted the revolutionary "cold-wave permanent" from Zotos (a business that still provides innovations in the professional beauty industry). The treatment offered "a holiday free from wires, machinery, electricity and cumbersome heaters."

The Higbee store marketed a "Miniature Fashion Dress-Designing Set" for young style enthusiasts that consisted of a twelve-inch-tall mannequin with removable arms, a sixty-four-page Simplicity Sewing book, four Simplicity Sewing patterns, a tape measure and fabric for one dress. The complete kit cost $1.94. A toy robot plane, which was handmade from balsawood

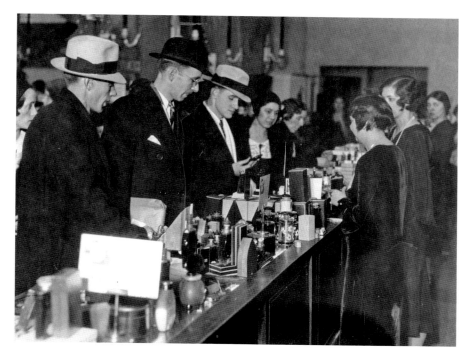

Above: A group of men, looking somewhat perplexed, shopped at the Halle perfume counter in 1931. By the 1950s, the downtown department stores were providing expert advice to men, women and children who needed assistance in selecting Christmas gifts. *Courtesy of the Cleveland Press Collection, Michael Schwartz Library, Cleveland State University.*

Right: The Taylor department store used postcards to notify customers of an upcoming 1941 pre-Christmas private coat sale. *Courtesy of the author.*

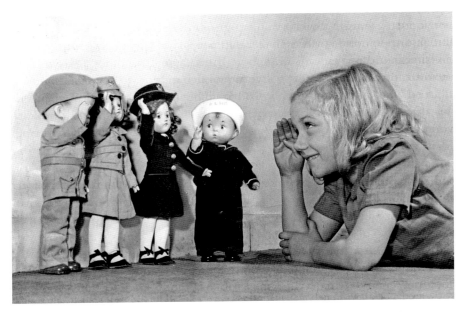

In 1942, dolls representing the branches of the United States Armed Forces (soldiers, sailors, WAACS and WAVES) joined with children in saluting America. *Courtesy of Cleveland Public Library, Photograph Collection.*

and included an adjustable launching platform, would climb and loop when propelled into the wind ($3.85). Last-minute gifts included an old-fashioned five-pound fruitcake ($5.00) and a miniature plastic "perfume clock" ($1.00) that served as a stopper for a bottle of perfume. The store promoted Frank Sinatra singing "White Christmas" ($0.52) as the first recording to employ a full orchestra in twenty-seven months, as the American Federation of Musicians had been on strike for more than two years. For the sportsman, durable air-rubber boats ("not army or navy life rafts but boats designed and built for hunters, fisherman and campers") cost $69.50 for a two-person boat and $79.50 for a three-person model.

According to its advertising, the Halle department store provided a guiding hand, suggestions and moral support for harried male shoppers who needed to fill long Christmas present lists with little time remaining. "Pretty ladies" recommended gifts in a matter of minutes, promising almost clairvoyant solutions for "your cousin's kids in Indiana or that rich aunt you were named for in Seattle." Inspired by the lyrics to "I'll Buy That Dream," a hit song at the time, a 1945 Halle advertisement declared:

The honeymoon in Cairo may have to wait, but this much of her dream can come true: licorice-stripped satins, languorous capes and sassy little quilted slack sets, part and parcel of a heavenly array of leisure fashions on the sixth floor. For the man, a leather gift can't help being successful because leather seems masculine. Our suggestions include leather-lined pigskin billfolds ($8.00), alligator belts ($7.00) and zipped-pigskin tobacco pouches designed to hold pipes ($3.50).

Other suggestions included necklaces, bracelets, brooches, rings, earrings, charms and pins ranging in price from $5 to $3,000 (plus the despised 20-percent Federal excise tax).

The May Company conducted lavishly large sales, showcasing thirty thousand colorful silk neckties at $1.00 each and ten thousand classical recordings that ranged from Ravel's "Bolero" ($0.33) to Mozart's "Symphony No. 40 in G Minor" ($1.89). The store's "accents on alligator" featured a handbag ($37.50) and matching shoes ($14.95). The comprehensive fourth-floor bookstore offered current bestsellers, such as Ernest Hemingway's *For Whom the Bell Tolls* ($1.40) and Pearl Buck's *Dragon Seed* ($1.00), and classics, including Leo Tolstoy's *War and Peace* and Sigmund Freud's *General Introduction to Psychoanalysis* (each $1.00). In 1946, kids turned their attention to peacetime toys, which comprised electric trains, dolls, dollhouses and buggies, sleds, cowboy suits and water pistols.

At precisely 1:00 p.m. on August 30, 1949, the Milgrim woman's fashion store relocated from Euclid Avenue to join four neighboring merchants on Huron Road, Cleveland's exclusive "Fashion Row." Downtown Cleveland shoppers observed firsthand what many people only witnessed in movies or newsreels. A chauffeur, attired in an immaculate uniform and cap, maneuvered a dark-colored Cadillac as close as physically possible to his wealthy employer's desired shopping destination. After opening the door for her, the driver assisted the dignified lady from the automobile to the sidewalk. A liveried footman employed by the retail establishment then escorted her across the sidewalk and into the shop. Dressed in a stunning mink coat in cold weather or an expensive pastel-colored light-weight suit in summer, the lady examined the merchandise to determine if anything met her needs or whims. The chauffer remained parked until the ritual reversed itself when she completed her shopping.

In 1914, Sally Noble, at the tender age of sixteen, married Charles Milgrim, a custom suit manufacturer in New York City. Sally entered the family business as a dress designer and soon grew the firm into an exclusive

The Milgrim's store anchored an upscale Huron Road shopping district. *Courtesy of Cleveland Public Library, Photograph Collection.*

Fifth Avenue retailer, where her creations appealed to wealthy customers, political wives and celebrities. In 1919, the May Company advertised itself as the Cleveland headquarters for Milgrim-designed dresses. In 1927, Milgrim opened a Euclid Avenue location in the Keith Building, joining the company's retail outlets on Fifth Avenue and in Chicago. Their first Cleveland Christmas offerings included dinner and evening gowns ($145 to $245), afternoon dresses ($125 to $175) and coats and wraps ($145 to $275).

William F. Engel, promoting himself as the "practical furrier," inaugurated the future Huron Road exclusive shopping district. In 1899, Engel co-owned a fur shop on what would become part of the site of the Terminal Tower. Two years later, he established his own store on Prospect Avenue, near East Ninth Street. In 1915, he and John Fetzer founded a new business on Huron Road. Engel-Fetzer remained on the street for more than five decades, although the company twice moved to larger sites. In 1922, robbers broke into an adjacent piano store, tore down a wall between the two businesses and confiscated more than one hundred of Engel-Fetzer's fur coats. Based on the company's excellent reputation within the industry, New York

manufactures quickly replaced the missing merchandise. During the 1944 Christmas season, the store promoted Persian lamb coats (starting at $495) as "a gift to wear with pride." The next season, the company advertised natural leopard fur coats "with a vital, youthful charm" starting at $795. For the 1946 holidays, Engel-Fetzer recommended "sensibly-priced" natural mink coats starting at $2,985.

In 1941, Harold and Earl Rogoff, both former employees of B.R. Baker (a Euclid Avenue clothing store founded in 1910), inaugurated their own men's furnishing business on Huron Road, which became the second "Fashion Row" establishment. In addition to its top-of-the line suits, slacks, jackets, sweaters and overcoats, the Rogoff store marketed smoking jackets and cashmere robes. In 1957, the firm promoted Louis Roth tailor suits ($155) as suitable Christmas presents.

Mary Louise, a ladies' dress shop that specialized in "exclusive apparel" opened on Euclid Avenue in the early 1920s. Their inventory included evening, dinner, afternoon and street dresses, evening gowns and wraps and coats. The company also focused on providing "correct attire when attending college and finishing schools." In 1942, Mary Louise relocated to Huron Road. Its Christmas offerings that year included furs, costume jewelry, bags, perfume, colognes, gloves and scarfs. In 1946, the store featured daytime dresses ($35 to $94), dinner dresses ($40 to $125) and coats and suits ($50 to $149).

New York–based Peck & Peck entered the Cleveland market in 1934, when it opened its fourth branch location (following Newport, Palm Beach and Miami Beach). The Euclid Avenue store relocated to Huron Road in 1944 and became the fourth "Fashion Row" business.

All five of these stylish downtown merchants eventually established satellite stores in Shaker Heights. Peck & Peck's South Moreland Boulevard location, which debuted in 1943, preceded the company's move from Euclid Avenue to Huron Road. In 1947, Mary Louise established a Kinsman Avenue (soon to be renamed Chagrin Boulevard) branch. Engel-Fetzer followed with a store in Shaker Square in 1950. Ten years later, Rogoff Brothers chose Van Aken Boulevard for its entry into Shaker Heights. In 1961, Milgrim located its first branch in the lobby of the Somerset Inn, where the cramped quarters required a fold-out dressing room that was stored in the wall when it was not in use.

The Radio Television Company of Cleveland, a small business on St. Catherine Avenue (a side street situated between East Ninety-Third Street and a set of railroad tracks) began business in 1925, when it manufactured,

sold and repaired radios. At the time, no commercial television sets had ever been constructed, nor had any television stations existed to transmit programs that were yet to be produced. Despite these challenges, the company's owners believed commercial television lurked just beyond the immediate horizon and desired to be among the first businesses to use the term. Inhibited by the Great Depression and World War II, twenty-two years passed (as did the Radio Television Company) before television became a viable reality.

Cleveland's first broadcasting station debuted in 1947. Two months in advance of the first television transmission, the May and Bailey Companies both advertised General Electric televisions with guaranteed delivery and installation before Christmas. The ten-inch picture tube, residing in a beautiful genuine-mahogany cabinet, cost $495 (the equivalent of $5,600 today) plus an installation charge. Newspaper advertising displayed a football player on the television screen as he prepared to crash through defenders to score a touchdown. Around the same time, Taylor's promoted a Philco television (which cost $795 in an attractive cabinet) with Bing Crosby on the screen, possibly singing "White Christmas" or his latest hit, "Now Is the Hour." A week before Christmas, the May Company stocked seven different television brands (RCA Victor, Philco, Belmont, Emerson, United States, General Electric and Stromberg-Carlson), which were all available as table models or attractive furniture and ranged in cost from $250 to $1,595 ($2,800 to $18,000 today).

Downtown Christmas Shopping

THE GLORY YEARS (1950s)

\mathcal{O}n the 1950s, downtown Cleveland remained shoppers' favorite destination for Christmas gift purchases. Automobiles jammed the streets, while pedestrians crowded sidewalks. On their shopping trips, women wore full-skirt dresses, fashionable hats, leather gloves and high heels. Men's apparel was composed of suits or sportscoats with pleated pants, brightly colored ties, fedora hats and wingtip oxford shoes. Free delivery and metal Charge-A-Plates, which were accepted at most department stores, added to the convenience of downtown shopping. Thrifty purchasers saved money by collecting and redeeming May Company's Eagle Stamps and Bailey's Merchant (red) Stamps. Department stores and specialty shops catered to almost every shopper's budget and fancies. Top-of-the-line dolls sold for $90, while a four-foot-tall, Italian-made elephant commanded $159.95.

Glimmering lights on Public Square blended with creatively decorated store windows to mesmerize not only children but parents and grandparents as well. A May Company window depicted Santa Claus watching an animated snowball fight between boys and girls in an outdoor turn-of-the-century setting. The Taylor department store used two of its Euclid Avenue windows to portray the nativity scene and the journey of the Three Wise Men. In this period, department stores incurred a cost between $5,000 and $10,000 to prepare their holiday display windows.

A year into the 1950s, Cleveland welcomed another high-end retailer to the fashion district. Bonwit Teller launched its fifth national store (joining

Christmas at the May Company in 1954 included Santa Claus, exciting window displays, colorful lighting and floors packed with merchandise. *Courtesy of Cleveland Public Library, Photograph Collection.*

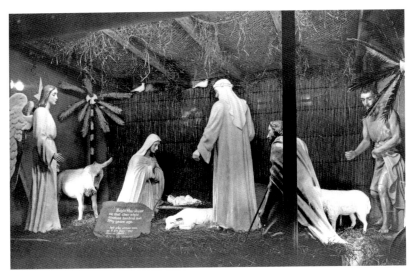

In the 1950s, the Taylor department store devoted a large Euclid Avenue display window to a portrayal of the nativity scene. This image is from 1954. *Courtesy of the Cleveland Press Collection, Michael Schwartz Library, Cleveland State University.*

New York City, Chicago, Boston and White Plains) on Euclid Avenue, nearly opposite the exclusive Huron Road shops. Decorated with French crystal chandeliers, Victorian chairs, Venetian furniture and eighteenth-century paintings and portraits, the company added another touch of retail class to the city. Designer clothes, furs, coats, suits and wedding dresses consumed the fabled second floor, while still-upscale but nearer-to-popular-priced casual clothing filled the remainder of the store. The management of Bonwit Teller did not tolerate mirrors with blue or off-color tints because, as an executive explained, "it makes the ladies look tired and in a poor frame of mind for buying."

The *Plain Dealer* described Euclid Avenue on the Friday following the 1953 Thanksgiving holiday as "something of a living river," as Christmas shoppers packed sidewalks from store entrances to the street curbs. A short automobile trip on Euclid Avenue from East Eighteenth Street to Public Square often required twenty minutes or more. The Cleveland Transit Company added one hundred extra buses to transport throngs of shoppers who were visiting downtown Cleveland. Even so, demand easily exceeded the available capacity. After finishing her workday, a secretary in a downtown office building began her homeward journey to East 110th Street and Superior Avenue by walking east on Superior Avenue because of the long and congested waits for buses. She reasoned that boarding a bus past the crowded downtown area would be well worth a walk of a few extra blocks. But buses, filled to capacity, couldn't stop for new passengers. An hour and forty minutes later, she completed her unplanned hike to East 110th Street. Meanwhile, other transit customers crammed into restaurants, choosing to dine with a crowd instead of battle for a place on an overloaded bus.

On March 13, 1954, Sterling-Lindner-Davis demonstrated the first color television in Cleveland, a Raytheon brand selling for $1,200 (about $11,000 today). Advertising claimed the television "not only gives full color on color broadcasts, but you can switch to black and white at the turn of the dial."

Downtown Cleveland's amazing shopping alternatives and festive allure seemed secure, not to be challenged in the foreseeable future—if ever. But by the mid-1950s, the winds of change began blowing away from downtown, following the population movement to the west, east and south. In 1954, Westgate, a large strip mall that was anchored by a Halle Department Store, debuted in the western suburb of Fairview Park, near the Rocky River border. That same year, the Shoregate Mall opened in the eastern suburb of Willowick. The Southgate Mall (situated in the southern

suburb of Maple Heights) opened with forty-four stores in 1955. The Taylor department store established a Southgate branch in 1958. In 1956, Parmatown opened with thirty-three shops and unveiled expansion plans even before the initial stores unlocked their doors. Also in 1956, the May Company added its "May's on the Heights" branch in University Heights and opened a Parmatown store in 1960.

Few people initially viewed the two- and three-story suburban branches as serious competition for the massive Euclid Avenue stores that had dominated Cleveland's retail business for more than a century. To some extent, history validated this view. Back in 1929, the Bailey Company opened a branch on Euclid Avenue at East 102nd Street, four miles east of downtown. The next year, the retailer created a suburban Lakewood store on Detroit Road. The company expanded again in 1951 to Lakeshore Boulevard in the suburb of Euclid and to the Eastgate Shopping Center in Mayfield Heights in 1959. The Halle department store operated a Shaker Square store beginning in 1948, and two years later, it began operating a Cedar Road branch in University Heights. Despite these expansions, downtown Cleveland endured as Northeast Ohio's mecca for Christmas shopping.

The Higbee Company, which had not yet ventured into the suburbs, appeared to be the most concerned about vulnerability due to suburban growth. To thwart the competitive threat, the downtown store (positioning itself as "The Christmas Store with More") developed special service areas for male, female and child shoppers. In 1956, the company established an "Answer Shop" filled with men's clothing. Male and female customers who were not totally comfortable with purchasing men's fashions relied on expert advice from knowledgeable salespeople. In its initial year, the shop stocked fifty-nine combinations of neck and sleeve sizes for Arrow shirts, most selling for $3.95. A $22.95 price tag accompanied washable McGregor "anti-freeze" jackets, which were lined with nylon fleece and offered in tan, marble brown, glacier blue and charcoal.

Debuting in 1957, the "Higbee Stag Shop," a women's Christmas gift store available only to men, promised, "A man will find Christmas finery for every lady on his list." The company assured its male customers that the "wise-in-the-ways-of-ladies'-fashion staff" will guide each customer to distinctively wrapped perfect gifts. The Higbee Company created its Twigbee Shop in 1959, which catered to children's Christmas shopping requirements for adults. With scaled-down fixtures and accommodating salespeople, children selected and paid for Christmas presents that were priced between twenty-five cents and three dollars. W.T. Grant, S.S. Kresge and F.W. Woolworth,

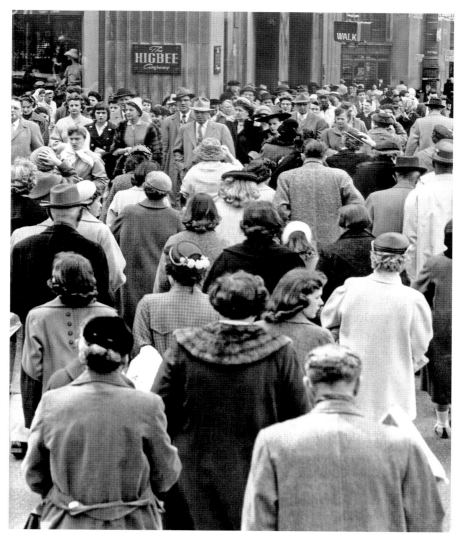

In 1958, Christmas shoppers congregated in front of the Higbee department store. *Courtesy of the Cleveland Press Collection, Michael Schwartz Library, Cleveland State University.*

all clustered on the south side of Euclid Avenue near Public Square, also welcomed child shoppers.

The variety of popular gifts in the 1950s reflected time-honored favorites, a fascination with new electronic wonders and an anxiety concerning the growing cold war. In 1951, the May Company's improved toy locomotive

 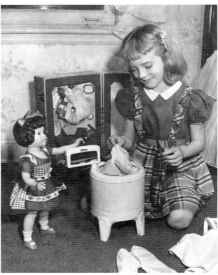

Left: The Twigbee Shop's 1959 debut allowed children to select and purchase Christmas gifts for their parents, relatives and friends. *Courtesy of Cleveland Public Library, Photograph Collection.*

Right: In the early 1950s, girls used a realistic toy washing machine to simulate their mother's weekly clothes washing ritual. *A Mattel publicity photograph courtesy of Cleveland Public Library, Photograph Collection.*

puffed smoke while emitting a "choo-choo" sound. The complete train set included an engine, hopper car, boxcar, caboose, uncoupler, twelve sections of curved track, a smoke capsule and a twenty-five-watt transformer; the entire package cost $23.95 (it would cost ten times as much today). In 1954, the May Company promoted a Christmas present that was especially coveted by teenagers: a three-speed portable record player and carrying case ($19.95). A few of the then-popular records, which were also available in the store, enhanced the gift's allure. Perfect for pajama parties, teens sang along with the Crew Cuts' "Sh-Boom," Eddie Fisher's "I Need You Now" and the Chordettes' "Mr. Sandman."

In 1955, the Taylor and Halle department stores introduced another electronic marvel: the twelve-ounce transistor radio. The Emerson brand, advertised as the world's smallest radio, sold for $44.00, while the competing Regency radio commanded $49.95. Advertising suggested that Dad, receiving a transistor radio as a Christmas present, could enjoy it all winter and spring and then check the latest ball scores while golfing in the summer. The gift was made even more pleasurable after adding a leather

In the 1950s, children's play kitchens became more realistic when Mattel introduced packages of edible cake mix and frosting, along with a functional mixer and oven. *A Mattel publicity photo courtesy of Cleveland Public Library, Photograph Collection.*

carrying case ($3.95), earphones ($7.70) and an extra battery ($1.25). Five years later, the Higbee Company offered transistor radios for $24.95; the price included the carrying case and earphones. By 1965, discount stores had cut the price to $10.00.

By the mid-1950s, the do-it-yourself craze had entered the children's market with toy sewing machines capable of sewing real clothing and cooking sets using actual canned soups and cake mixes. Reacting to publicity associated with heightening disputes between the United States and Russia, children embraced gifts of missile launchers, long-range atomic cannons, cap-firing machine guns and army tanks and trucks.

In 1959, the Bailey company accumulated the largest selection of dolls in its history; the display absorbed almost a half-block of floor space. For kids who were not interested in dolls, a ninety-piece Fort Mohawk set included a stockade, soldiers, Native Americans, a cannon, bows and arrows, horses and more. A sixty-piece Wyatt Earp assortment came equipped

with a stagecoach, a metal Dodge City building and cowboys and Native Americans. The company slashed the price of both collections from $6.00 to $3.00. Sale items also featured timeless favorites, such as Monopoly ($2.69) and erector sets ($12.88).

The rise of discount retailers, some national in scope, burdened regional department stores with serious competition. In 1947, Giant Tiger operated two salvage stores on Euclid and Chester Avenues near downtown. Two years later, the company expanded with the opening of Super Discount stores. By the decade's end, Giant Tiger had established ten stores in Greater Cleveland, selling everything from pajamas and bobby socks to rum-butter fruitcakes and automobile antifreeze. Fats Domino, a singing superstar of the period, even appeared in person to launch one of these stores. Giant Tiger's discount prices lured shoppers away from downtown and into the inner city and suburbs. During the 1958 holiday season, the company advertised hi-fi consoles with AM/FM radios discounted from $188.95 to $99.88. A three-foot-tall vinyl doll ("as big as a three-year-old child and almost as real") was reduced from an advertised sticker price of $29.95 to $9.77. Giant Tiger marked down record albums from $3.95 to $2.88. The holiday offerings included *Sing Along with Mitch Christmas Carols* and an Elvis Presley Christmas album that comprised thirteen songs, including "White Christmas" and "Silent Night."

Uncle Bill's debuted in 1955. First concentrating on appliances, the discount store exhibited washers and dryers manufactured by recognized companies of the day (Bendix, Maytag, Whirlpool and Norge). The company expanded and became a major competitor of Giant Tiger and other existing department stores. In addition to lower prices, the two discount stores gained sales by opening on Sunday, which was in violation of the state's long-standing "blue laws." Although police raided the stores and courts pronounced the owners guilty, the usual twenty-five-dollar fine plus court costs represented a small price to pay when considering the competitive advantage that was gained by selling merchandise on a day when other retailers remained closed.

During the 1958 Christmas season, the *Plain Dealer* headline "Kidnapping on Public Square" previewed another menace to downtown shopping, which erupted in full force in the 1960s and 1970s. A youth jumped into a car that was waiting at a Public Square traffic light, drew a gun and forced the driver to travel to East Forty-Ninth Street, where a second criminal waited to assist in robbing the driver. Both petty and violent crime would threaten downtown Christmas shopping for the next twenty years.

Downtown Christmas Shopping

THE GLOOMY DECLINE (1960–PRESENT)

*O*n 1961, Christmas shoppers maintained their annual journeys into downtown Cleveland to purchase presents in six major department stores, a variety of jewelers and numerous specialty shops. The retailers on Euclid Avenue, from Public Square to Playhouse Square, along with the Bailey company on Ontario Street and the posh stores on Huron Road, supplied gifts that ranged from mundane to exotic and came in nearly any size, shape, color and price range.

Beginning at Public Square, the Higbee Company had expanded its shopping options by converting its tenth-floor auditorium and lounge into temporary retail space. Including the bargain basement, the company offered Christmas shoppers eleven floors of gifts and excitement. In contrast, no suburban department store exceeded three floors in height. The annual Answer Shop and Stag Shop consumed a portion of the ground floor. Holiday cards and gift-wrapping assistance resided on the second floor. Doting aunts and indulging grandmothers acquired the store's "loveliest gifts for children" in the fourth-floor Sugar Plum Shop. A home holiday furnishing boutique resided on the sixth floor. On the eighth floor, radios and televisions filled the Happy Holiday Shop with mirth and music.

Along with the Twigbee Shop, Higbee's top floor housed Santa's Wonderland, where children chatted with Santa Claus and marveled at an "Outer-Space Spectacular," complete with images of creatures residing on Mars, Venus and Saturn. In the toy department, kids loved Buttons, a battery-operated cocker spaniel who waged his tail, flapped his ears,

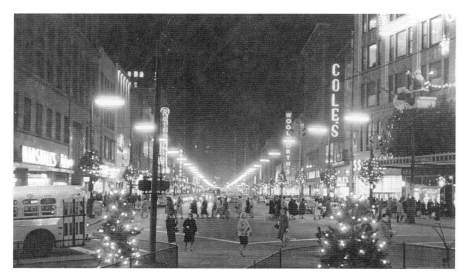

In 1961, Euclid Avenue's numerous retail stores offered a wide variety of Christmas gifts, ranging from mundane mass-produced items to unusual specialty presents. *Courtesy of Cleveland Public Library, Photograph Collection.*

barked, winked with one eye at a time and turned his head, all at the press of a button. The tenth floor also housed the International Gift Center, which offered presents imported from around the world; the Family Fun Center, which was stocked with games, records and books for children and grownups; and the Trim-a-Tree and Trim-a-Home shops that "pointed the way to gaiety all through the house."

The May Company offered imported English and Scottish tweed winter coats from $79.98 to $99.98. Bargains for men included Van Heusen's monogramed dress shirts ($5.00) and two-pant California-style suits ($59.95). The company's extensive record collection featured stereo versions of the soundtrack to Elvis Presley's *Blue Hawaii* ($3.98), the original cast recording of *How to Succeed in Business Without Really Trying* ($4.98) and *Mario Lanza Sings Christmas Carols* ($4.98). As one of the season's most unique gift offerings, the May Company marketed a choice of automobile driving lessons: four hours ($19.95), nine hours ($39.90) and sixteen hours ($59.95). Meanwhile, children received free rides on the North Pole Express.

Shoppers at the Bailey department store chose mink stoles ($199), mink-trimmed coats ($50), a white "pretend stole" ($12) and men's cardigan sweaters ($5.99).

Christmas china from the Halle department store contributed to making both large and small 1963 holiday dinners even more memorable. *Courtesy of Cleveland Public Library, Photograph Collection.*

The Halle department store's regal mink jackets commanded $1,498.00, while long-sleeve ladies cashmere sweaters were sold for $15.98. With a pull of a magic ring on her back, Chatty Cathy ($14.77), the first large-scale production doll, spouted out recorded messages, randomly gushing "Please brush my hair." "Where are we going?" "I'm hungry." and "May I have a cookie?" among her eleven phrases. Those who desired the ultimate shopping experience reserved a room at the Statler Hotel anytime between 8:00 a.m. and 10:00 p.m. and parked their car in a nearby lot. The Halle Company delivered purchases to the hotel at the time selected by the customer. The entire package cost $4.00 per room. If a child needed a nap, a babysitting service charged $1.00 an hour.

The Sterling-Lindner-Davis department store enticed shoppers with mink coats reduced from $3,000 to a rock-bottom $1,499. Much-less-expensive holiday hand towels combined a rather fatigued-looking Santa with the inscription, "After traveling 24,862.52 miles, would you look any better?" Sterling accepted old bicycles as trade-ins for the latest improved models. A brand-new bike with a two-toned saddle, cantilever frame and whitewall tires cost $29.00 (plus a trade-in bicycle). For an additional $6.00, the Christmas gift could be upgraded to a black English three-speed racer with chrome headlamp and a rear-view mirror. A deluxe model, equipped with twin chrome headlamps, a horn, chrome rims and a rear-view mirror (available in red for boys and blue for girls) commanded $44.00. Less-expensive toys included a battery-powered green plastic monster named the Great Garloo ($13.94), make-believe refrigerators ($12.95), washer and spin dryers ($17.66), a Flintstone playset, including all the characters from the television show ($4.87), and a remote-control convertible ($2.98). Sterling promoted its first-floor toy department as the only downtown store that did not require kids to travel on crowded escalators or elevators to reach the coveted toys.

Within three blocks of each other, a trio of Euclid Avenue jewelers promoted an amazingly wide range of Christmas gifts. H.W. Beattie & Son advertised diamond rings that cost $10,688.00 (about $92,000.00 in today's money). Rudolph Deutsch priced diamond earrings at $2,700.00 and fourteen-karat gold and diamond bracelet watches from $275.00 to $425.00. For the more budget-minded shopper, Cowell & Hubbard suggested International Sterling candelabras that had been marked down from $140.91 to $99.50.

The Traveler's Shop touted a solid bamboo folding travel cane (useful for attending the symphony or opera) for $22.50 and briefcases from

$3.95 to $88.00. A more unusual gift, an empty beer can launcher ("designed for practicing hunters or people just looking for fun") carried a $23.50 price tag.

Entering Cleveland's high-fashion neighborhood, Bonwit Teller advertised chinchilla bolero jackets for $2,500. Other Christmas gift suggestions included mink stoles starting at $695 and ladies' dress shirts in the latest styles starting at $40. Across the street on Huron Road, Engel-Fetzer marketed wild Canadian mink full-length coats ($4,900) and stoles ($1,595). Mink-collared cashmere sweaters ranged from $110 to $179. Next door, Mary Louise charged $365 for a matching trio composed of a three-piece suit made from diagonally chalk-stripped red wool, a matching fringed stole lined with white lamb and a white crepe blouse. The fashionable dress shop also advertised "intimate apparel for giving or keeping" and promised "every item beguiling and different as snowflakes… exciting as Christmas itself."

Peck & Peck offered V-neck cashmere sweaters dyed in Glengerry gold, Dundee rose, Gleneagle green or plain black ($26.95) and a coordinated wool plaid slimskirt with leather-trimmed pockets, available in gold and spice, rose and green or green and blue ($19.95). For a less expensive gift, Peck & Peck promoted a miniature gold-colored travel stapler that was operated by pressing down on a reproduction of a coin mounted on the handle; the $4.00 price included a red leatherette case.

The Milgrim shop offered red mink stoles from $495 and jackets from $895. An Italian fur-trimmed, black leather folding garment bag decorated in a multicolored needlepoint pattern sold for $115. The company displayed its sense of humor by selling a huge, eighteen-inch walnut pencil with the imprinted caption "For Those Really Big Deals" ($2.50).

Regrettably, a few weeks of crowded December stores couldn't sustain downtown shopping, as suburban retailers acquired the growing bulk of the customers during the remainder of the year. Visible signs of the then-inevitable decline had already made their presences. Amid the 1961 Christmas merriment, shoppers strolling down Euclid Avenue witnessed the Taylor department store's going-out-of-business sale. Three months later, the Bailey Company ended its long tenure on the corner of Prospect Avenue and Ontario Street. The company relocated to the first two floors of an eleven-story building on Prospect Avenue and merged with Miracle Mart in 1963. Five years later, the downtown and suburban Euclid and Mayfield Heights stores were converted into Bailey's Wonder Marts but ended their existences in bankruptcy within a year.

As the 1960s continued, department stores' unabated movements to the suburbs gathered increasing momentum. The May Company added stores in Southgate (Maple Heights), the Great Lakes Mall (Mentor), Great Northern Mall (North Olmstead) and Cleveland Heights. Higbee's opened stores in Westgate, the Great Lakes Mall and Parmatown. Halle Company stores debuted in Shore Center (Euclid) and the Great Lakes Mall.

On October 17, 1963, downtown retailing suffered what was arguably its most crippling single blow. With the Halle and Higbee department stores as anchor tenants, the massive 151-acre Severance Center debuted in Cleveland Heights as the first fully enclosed regional mall in Ohio. Peck & Peck, Engel-Fetzer and Milgrim's, vital mainstays of Huron Road's high-end shopping district, soon launched Severance Center branches. The mall placed full-page advertisements in Cleveland newspapers, advising shoppers that there was no need to shop downtown anymore. Severance Center's customers enjoyed air conditioning in summer, warmth in winter and free year-around parking. Some already-existing strip malls soon reconfigured themselves as enclosed malls.

In 1964, the May Company attempted to reverse the decline in downtown sales (a trend it helped create with suburban expansion) by constructing a ten-level attached parking garage on the site of the former Bailey Company. Shoppers paid ten cents each half-hour with any May Company purchase and twenty cents without a purchase. Customers entered the May Company directly from any of the parking garage's first six levels.

The May Company introduced innovative toys in the 1960s, including Baby Pattaburp, a doll that made a burping sound when patted on the back, and "V-Rroom," a bicycle with heavy-duty shock absorbers, a double-frame of rugged steel, a Bendix break system, reinforced wheels with extra spokes and an optional sound unit that created a roar like a motorcycle in dire need of a muffler. Toy dump trucks soon followed; they had the capability to unload, back up and race and roar an idling motor. A "Big Bruiser" tow truck came equipped with a power hoist, siren, flashing lights, reverse controls and a damaged car (complete with a replacement fender and spare tire) that kids towed to a toy garage. A miniature electric stove actually baked real cakes using small boxes of genuine cake mixes. Erector sets adapted to the times and came with components used to construct rocket launchers. The unpopular Vietnam War discouraged parents from purchasing toy guns, but weapon systems inspired by *James Bond* and *The Man from U.N.C.L.E.* developed into top sellers.

The Higbee Company's Twigbee Shop items then ranged from twenty-five cents to five dollars. In 1967, the shop expanded beyond Christmas gifts

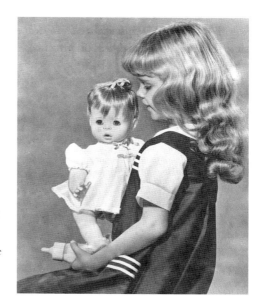

When patted gently on the back, Mattel's Baby Pattaburp made a burping sound. A "magic bottle' allowed the milk to disappear as she drank from it. Introduced in 1963, the doll was available at most downtown department stores. *A Mattel publicity photo courtesy of Cleveland Public Library, Photograph Collection.*

and began stocking Mothers' Day presents, including jewelry, perfume and soap, and Fathers' Day gifts, including cologne, handkerchiefs and stockings. Youthful shoppers could even shop for the family pet—cheese-, taco- and licorice-flavored bones for dogs and catnip and toys for cats. Introduced in 1986, the Twigbee Bear was Santa's official helper. According to his backstory, one snowy Christmas Eve, when Santa lost his Cleveland street map, the bear just happened to be on Public Square and helped Santa find his way and deliver presents. A grateful Santa took the Twigbee Bear to the North Pole to work with him, but the bear returned to spend his holidays at the Higbee Company. The official Twigbee Bear cost ten dollars with purchases of fifty dollars anywhere in the store. In 1990, when the Higbee Company converted the tenth floor into an office space, the shop relocated to the adjoining Tower City Mall.

The 1960s claimed its third downtown department store casualty when Sterling-Lindner-Davis closed in 1968. The exodus from Huron Road's high-fashion area commenced the same year with the departures of Engel-Fetzer and Rogoff Brothers. Milgrim followed in 1971, and Peck & Peck followed in 1972. When Bonwit Teller closed in 1972, only the struggling Halle department store and Mary Louise remained in the once-vibrant shopping district that was anchored by high-end merchandisers, two major department stores, excellent restaurants and five beautiful theaters. Mary Louise shuttered its doors in 1974, and the Halle store closed in 1982.

Above: A new electric wonder, the affordable countertop microwave oven, was ready to use after removing the ribbon in 1972. *Courtesy of Cleveland Public Library, Photograph Collection.*

Right: Viewed from within the store, a 1970 May Company Christmas window depicted an aminated scene. Curious shoppers and the Williamson Building comprised the background outside the store. *Courtesy of Cleveland Public Library, Photograph Collection.*

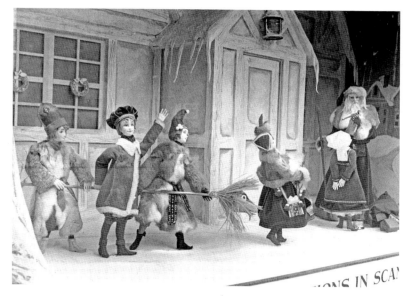

A Scandinavian Christmas scene filled a Halle display window during the 1971 holiday season. *Courtesy of the Cleveland Press Collection, Michael Schwartz Library, Cleveland State University.*

In 1973, despite suburban competition and a perception of increased crime, downtown shoppers filled the Higbee Company. *Courtesy of the Cleveland Press Collection, Michael Schwartz Library, Cleveland State University.*

Retail's influx into suburbia continued in the 1970s. In 1976, the May and Higbee Companies opened stores in the new Randall Park Mall in North Randall, which was then promoted as the largest indoor shopping mall in the world. The following year, the same two stores joined the new Euclid Square Mall in Euclid, Ohio. In 1978, Higbee's opened its third suburban location in as many years by coanchoring the new Beachwood Place Mall. Even as downtown's decline intensified, the *Plain Dealer*, in 1977, praised its distinctive ambience: "A walk down Euclid Avenue beats twice as many acres of sterilized shopping malls. You can't duplicate the animated window displays in downtown stores, let alone the charge of energy that surges through the streets." That year, a Halle Company window presented animated scenes of sledding and skating in a Currier and Ives setting. The next year, the department store dedicated seven display windows to animated scenes form *A Christmas Carol*, but the May Company abandoned Christmas themes in favor of displaying merchandise in its windows.

Above: A Higbee Company Christmas window is viewed in 1980 by a five-year-old-boy and his nine-year-old sister. *Courtesy of the Cleveland Press Collection, Michael Schwartz Library, Cleveland State University.*

Opposite: The Fifth Street Arcades (two beautiful passageways connecting Euclid and Prospect Avenues) have been meticulously restored and now comprise a blend of unique boutiques and service establishments. *Courtesy of the author.*

In each of the twentieth century's last three decades, downtown Cleveland developed attractive new shopping environments (Park Center in the mid-1970s, the Galleria in 1987 and the Tower City mall in 1990). All three attempts failed to sustain enough business to succeed as high-end retail centers. In 1992, the May Company's final downtown after-Christmas sale attracted bargain hunters who were making their first shopping trip downtown in a decade or more. The May Company had operated in downtown Cleveland since 1899, and it had operated in its then-current site since 1914. The store closed on January 31, 1992, finally succumbing to suburban competition.

The Dillard department store chain purchased the Higbee Company in 1992, and it soon consolidated the Public Square store's merchandise onto four floors. Amid burned-out lights, a torn carpet patched with duct tape and paint peeling from the ceiling, the store closed on December 31, 2001, a painfully feeble ending to Cleveland's downtown department store era.

Christmas and the Arts

No United States ballet company had ever produced a full-scale production of *The Nutcracker* until 1944. The San Francisco Ballet first accomplished the undertaking more than half a century after the Russian Imperial Ballet's 1892 premiere of the Tchaikovsky classic in St. Petersburg. In 1932, the Cleveland Orchestra presented a portion of *The Nutcracker* score along with animated toys dancing around a Christmas tree. The following year, the orchestra substituted a ballet group as a more fitting accompaniment. In 1935, the YMCA School of Dance offered an abbreviated version of *The Nutcracker* in the tenth-floor auditorium of the downtown Higbee Department Store.

In the 1960s, Clevelanders paid less than five dollars to enjoy the largest Broadway musicals at the Hanna Theater and Music Hall, while football fans chose six-, eight- and ten-dollar seats to cheer the Browns on to a 27–0 championship victory against the Baltimore Colts. Meanwhile, the Stars of the Bolshoi Ballet and Leningrad Kirov Ballet both commanded ten dollars for the best seats for their Music Hall presentations, each including a streamlined version of *The Nutcracker*.

In 1965, the Cleveland Orchestra and Dayton Civic Ballet finally combined to stage Cleveland's first full-length performance of *The Nutcracker* in Severance Hall. At the Music Hall, the National Ballet of Canada presented complete performances in 1966, 1968, 1969 and 1972, the latter featuring Rudolf Nureyev. In 1973, a performance by Ballet Spectacular included Dame Margot Fonteyn as the lead performer. By

the end of the 1970s, Cleveland pointed with pride to the city's newest production of *The Nutcracker*.

Northeast Ohio native Ian (Ernest) Horvath started ballet lessons to strengthen his body following an attack of polio. At the age of fifteen, he landed a probationary apprentice position at the old Musicarnival theater. Setting his sights on New York, Horvath appeared in *Funny Girl* on Broadway and danced with the New York City Opera Ballet, Joffrey Ballet and American Ballet Theatre. In 1972, Horvath and Dennis Nahat, both principal dancers with the American Ballet Theatre at the time, launched new careers as the directors of the recently formed Cleveland Dance Center. Two years later, the pair announced plans to develop a new ballet company in Cleveland. Horvath anticipated the organization would someday perform at the downtown Ohio Theater, which was then in a depressing state of disrepair. He told reporters, "The Ohio Theater is 50 percent of the reason I am in Cleveland. You couldn't build a theater like that today. If it was fixed up, it could be one of the best theaters for dance in the country." The Ohio Theater did undergo a splendid "fix up" and became an outstanding venue for dance, but the Cleveland Ballet never called it home.

Horvath and Nahat developed an original Christmas ballet, which premiered in 1977 and attracted near-capacity audiences for two seasons at the Hanna Theater. *The Gift* presented both sacred and secular views of Christmas. In "The Way to Bethlehem," the journey of Joseph and Mary is augmented with villagers, beggars, thieves, harlots and aristocrats. "Victorian England" depicts a poor family expecting an unhappy Christmas when the household's father is required to sweep a chimney. Employing fifty-six performers, seventy-nine costumes and creative lighting and scenery, the ballet served as a preview of the soon-to-debut *Nutcracker* spectacle.

Clevelanders' beautiful bond with the Cleveland Ballet's *The Nutcracker* began on December 12, 1979. The lavish productions combined excellent dancers, magnificent costumes and stunning scenery with a talented orchestra. Many insiders considered the initial $425,000 production to be an enormous gamble, but fifty-five thousand customers proved them wrong by packing the Music Hall during a nineteen-performance run that generated a $74,000 profit. Throughout the 1980s and 1990s, *The Nutcracker* generated capacity engagements, even when added performances eventually consumed an entire month. Although it was artistically excellent and enthusiastically supported by local businesses and audiences, the financially troubled company ceased to exist following the cancellation of the remainder of the 2000–2001 season.

The Cleveland Ballet's production of *The Nutcracker* enthralled Clevelanders for twenty-one years. *Courtesy of Cleveland Public Library, Photograph Collection.*

Within one week of the company's demise, Gladisa Guadalupe, one of the company's principal dancers, announced her formation of a new school, which she christened the Cleveland School of Dance. In 2014, the Cleveland Ballet returned with Gladisa Guadalupe as the artistic director and Cynthia Graham (an original member of the former Cleveland Ballet) as the ballet mistress. Three years later, a new version of *The Nutcracker* attracted sellout performances at the Hanna Theater. This latest iteration of the famous ballet is increasing in popularity each season.

Two very nontraditional versions of *The Nutcracker* have emerged in recent years. Playhouse Square has hosted a touring hip-hop version of the Christmas classic. Set in a New York City nightclub, the production employs Tchaikovsky's classic music but replaces the ballet steps with always energetic and often spectacular hip-hop dancing. For decades, Clevelanders have enjoyed *Nutcracker* performances highlighted by the hero's clashes with the mouse king, Christmas parties set in a Victorian home and dances by a sugar plum fairy. Courtney Laves-Mearini, the artistic and executive director of the City Ballet of Cleveland, decided the familiar story needed an update to a more recent time and place—specifically, Cleveland in the 1920s. In her annual *The Uniquely Cleveland Nutcracker* presentation, Victorian guests are replaced by members of Cleveland's famous Gund, Severance and Mather families. Charles Brush, the city's pioneering lighting entrepreneur

supersedes Drosselmeyer as the Christmas tree lighter. The mouse king and nutcracker battle scene is now a confrontation between a Brooklyn Dodgers pitcher and Cleveland Indians teammates during the 1920 World Series. In the Land of the Sweets, representatives from Cleveland's diverse ethnic groups engage in dance sequences.

The former Akron-based Ohio Ballet presented its interpretation of *The Match Girl* during the Christmas season at the Ohio Theater (in 1984 and 1991) and State Theater (in 1985). In some ways the polar opposite of the joyful *Nutcracker*, the production recounts the poignant Hans Christian Andersen tale of a destitute girl freezing to death while selling matches in the street.

Following the Great Lakes Theater Festival's relocation to Playhouse Square, artistic director Vincent Dowling searched for an appropriate 1982 Christmas production. He removed one classic drama from consideration almost immediately, informing the media, "We are obviously not going to be doing *A Christmas Carol*. That is well represented here." Dowling chose *A Child's Christmas in Wales*, an adaptation of poet Dylan Thomas's memoirs of his own childhood holidays in a small Welsh town. The production generated good business but proved to be a disappointment in a return engagement the next season. In 1985, the new artistic director, Gerald Freedman, selected *Take One Step*, a modern musical version of the classic Pied Piper tale, as Great Lake's 1985 holiday attraction. Although it was not a failure, attendance didn't warrant a revival the following year, so Freedman continued to look for the company's elusive Christmas blockbuster.

The Cleveland Playhouse had staged *A Christmas Carol* for eight consecutive years, from 1980 to 1987. In 1988, a new artistic director removed the classic from the company's repertoire to provide the Dicken's story a temporary respite. Sensing an opportunity, Freedman immediately started to work on a new version that was to debut during the 1989 holiday season. Following its first performance, theater critic Marianne Evett began her review with this opening sentence: "It looks as if Cleveland has a new Christmas tradition." She finished her glowing appraisal by concluding, "I see no reason to suppose it couldn't run for every holiday season until Doomsday." So far, her prediction has proven to be correct.

During World War I, acclaimed poet and playwright Langston Hughes attended classes at Cleveland Central High School and the Karamu House, the latter located about a block from his home. In 1980 and 1981, the Karamu House presented an adaptation of Hughes's off-Broadway success *Black Nativity*. The first half of the gospel-themed production ("The

Child Is Born") focuses on the birth of Christ, while the second half ("The Word Is Spread") concentrates on the present day. Following two seasons in the lobby of the State Theater (1982 and 1983), *Black Nativity* moved to the auditorium of Cuyahoga Community College's Metro Campus for three holiday seasons. The show then returned to the Karamu House. After a year at the Liberty Hill Performing Arts Theater, Karamu presented the show annually from 1993 to 2008, and the programs in 1995 and 1996 were staged at the downtown Music Hall. Since then, productions of *Black Nativity* have been mounted by Karamu four more times (in 2010, 2011, 2015 and 2018).

In 1983, Clevelanders witnessed an unusual Christmas parade in mid-January. One hundred vintage 1940s automobiles and a mockup of an antique streetcar cruised around Public Square while driving past the Higbee department store, which was decked out in 1940s holiday season decorations. The movie *A Christmas Story* used Cleveland as a surrogate for a World War II–era northern Indiana steel town. Although it was an initial box office disappointment, the film's popularity skyrocketed because of the holiday-season television exposure it gained in TBS's marathon

The West Eleventh Street home where *A Christmas Story* was filmed is now a tourist attraction. A giant version of Ralphie Parker in his "pink nightmare" pajamas is located on the right side of the home. *Courtesy of the author.*

twenty-four showings. The movie created two unexpected local legacies: a holiday stage production and a near-westside house developing into a tourist attraction.

In 2005, the Cleveland Playhouse introduced a stage version of the then generation-old movie. The popular production is now a perennial holiday presentation at the downtown Allen Theater. In 2004, a San Diego entrepreneur purchased the West Eleventh Street home, sight unseen, where *A Christmas Story* was filmed, and he restored it to appear as it did in the movie. An immediate sightseeing hit, the home and surrounding area have continued to develop into a mecca for fans of the movie. The home itself and its next-door neighbor are available for overnight rental. Two homes across the street have been converted into a museum and gift shop. Within a few steps of the home, the Rowley Inn offers a variety of dining options.

From the mid-1950s to the late 1960s, movie studios released many of their most anticipated films during the Christmas season. Crowds crammed downtown movie theaters to view *Quo Vadis?*, *The Ten Commandments*, *Around the World in Eighty Days*, *Mary Poppins*, *The Sound of Music*, *Thunderball* and many other hit films. A few of the era's most popular Christmas attractions failed to create themes of peace and goodwill. At the Hippodrome, *Peyton Place* filled the giant screen with homicide, suicide, incest and child abuse. The Stillman's *Solomon and Sheba* featured a shocking (for its time) orgy to a pagan god. The Palace's *Valley of the Dolls* depicted backstabbing, suicide and alcohol and drug addiction.

In the 1940s, three motion pictures, which are considered Christmas classics today, all missed holiday openings by a wide margin: *Holiday Inn* debuted at the State Theater in August, *It's a Wonderful Life* opened at the Palace Theater in February and *Miracle on 34th Street* began its initial showing at the Allen Theater in June. Also in the 1940s, Judy Garland began singing "Have Yourself a Merry Little Christmas" in *Meet Me in St. Louis* exactly one month late. The film opened at the State Theater on January 25, 1945. The Hippodrome Theater misfired by unveiling *Christmas Holiday* in August and both *Christmas in Connecticut* and *Come to the Stable* in September. The Palace Theater delivered a confusing message when *Christmas in July* actually did debut during the December holiday season. In 1951, the State Theater's *The Lemon Drop Kid* (famous for introducing the holiday song hit "Silver Bells") debuted in May.

The Stillman Theater seemed especially adept at missing its holiday timing. In November 1934, the theater hosted the world premiere of *Babes in Toyland*, but the film played for only one week. The movie *Christmas Eve*

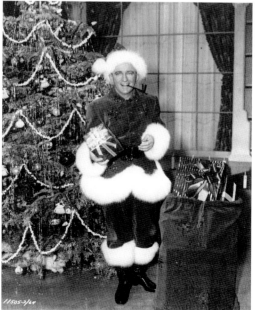

Above: The Christmas movie classic *It's a Wonderful Life* began its Palace Theater two-week run on February 6, 1947. *Courtesy of Cleveland Public Library, Photograph Collection.*

Left: The Stillman Theater's seven-week booking of Bing Crosby in *White Christmas* in 1954 didn't play on Christmas Day. *Courtesy of Cleveland Public Library, Photograph Collection.*

debuted on January 22, 1948. Six years later, *White Christmas* completed its seven-week booking on December 16, nine days short of the actual holiday. In 1960, Academy Award–winning *The Apartment*, which is set during the holiday season in contemporary New York City, began a seven-week run in June.

Notwithstanding ongoing technical revolutions, radio broadcasts of Christmas music are still commonplace. According to Nielsen Company ratings, Cleveland radio stations played Christmas-themed songs forty-eight thousand times during the 2015 holiday season, ranking number one in the country for broadcasting Christmas music. Nielsen did not report the top recordings by individual cities, but nationally, the five most-played songs were "Feliz Navidad" (Jose Felliciano), "Rockin' Around the Christmas Tree" (Brenda Lee), "Jingle Bell Rock" (Bobby Helms), "A Holly Jolly Christmas" (Burl Ives) and "All I Want For Christmas Is You" (Mariah Carey).

Index

T

W

About the Author

Since native Clevelander Alan Dutka retired from his business career, he has authored eight Cleveland history books: *Cleveland's Millionaires' Row*; *Slovenians in Cleveland: A History*; *Historic Movie Theaters of Downtown Cleveland*; *Misfortune on Cleveland's Millionaires' Row*; *AsiaTown Cleveland: From Tong Wars to Dim Sum*; *Cleveland Calamities: A History of Storm, Fire and Pestilence*; *East Fourth Street: The Rise, Decline, and Rebirth of an Urban Cleveland Street*; and *Cleveland's Short Vincent: The Theatrical Grill and Its Notorious Neighbors*. During his business career, he authored four marketing research books, including *Customer Satisfaction Research*, a primary selection of the Newbridge Executive Book Club that has been translated into Spanish and Japanese. Dutka is a popular speaker at historical societies, libraries, community centers and the Music Box Supper Club. He has appeared on the *Feagler & Friends*, *Applause* and *Seven Minutes with Russ Mitchell* television programs, and he has appeared on radio programs, including Dee Perry's *Around Noon* and Jacqueline Gerber's morning program. He has been interviewed by PBS, the *Lorain Morning Journal* and France 24 Television.

Visit us at
www.historypress.com
...